"Sylvie Vanhoozer is a marvelo
during Advents in Provence; her theological pilgrimage in Paris, Cambridge, Edinburgh, Chicago, and beyond; her passion and work as an artist; and her many years of ministry as a homemaker, mother, and host to hundreds in her home during Advent and Christmas have prepared her to write this very book. Follow her lead as you ask the Lord to come into your context. You and your loved ones will be forever grateful."

Douglas A. Sweeney, dean and professor of divinity at Beeson Divinity School

"A charming, enriching series of reflections that sheds light on some familiar aspects of Advent (traditional carols) and introduces us to new ones (especially the santons, the Provençal villagers who make their own pilgrimages to pay homage to the Christ child, gifts in hand). Lovingly highlighting the terroir, native plants, and local customs, these vignettes show how ordinary saints made the Son's incarnation their own in ways that resonate today, spurring us to attend to the unique features of our own place, ponder these connections, and await expectantly the appearance of Christ each day."

Elizabeth Sung, visiting associate professor of theology at Regent College

"Here is a book to make artists of us all, an invitation to experience Advent as never before. Bringing together beauty and worship, Scripture and daily life, anticipation and adoration, this lovely book offers a new pathway, in the company of charming saints and their most intriguing custom and culture. Here is richness worthy of the season."

Linda McCullough Moore, author of *The Book of Not So Common Prayer*

"For many, Christmas has become overly familiar. We know the shepherds and wisemen, Mary, Joseph, and Jesus in the manger. Sylvie Vanhoozer provides a great gift in this book by introducing another Christmas story, that of the saints in Provence, one that will be fresh for many readers so that we might be awakened to the arresting power of its origin story, God dwelling among us, first in first century Bethlehem, thereafter in our times and places. A guide for the entire season, this veritable feast of image, flora, story, and Scripture provides an easily digestible yet incredibly nourishing morsel of wisdom and encouragement for each day. As readers journey through the book and the season, they are equipped to plant the seeds that have such fertile ground this time of year in those they love, just as they were planted and bloomed for the author herself. I look forward to walking through the journey of Advent with this book, sharing it with others, and living 'adventish' always!"

Amy Peeler, Kenneth T. Wessner Chair of Biblical Studies at Wheaton College and author of *Women and the Gender of God* and *Hebrews: Commentary for Christian Formation*

"Most of us know the story of Mary and Joseph, the crib, the shepherds, the Magi, and the angelic choir. Sylvie Vanhoozer retells the story through the lens of the Provençal crèche she grew up with. Her purpose is not to invite us to travel to southern France but to help us translate this magical depiction of the birth of the Savior into our own lives. The crèche scene is animated by the santons ('little saints'), where each figurine represents a typical villager, reminding us of God's love for ordinary people. And it not only articulates our waiting for God but God's waiting for the right time. Sylvie's exquisite devotional guide through the season of Advent helps us grasp the true meaning of our hope and thus our encounter with the Savior."

William Edgar, professeur associé at the Faculté Jean Calvin

"Lessons from Advent don't have to be boring, and this book is proof. There are fresh ways to inspire, inform, and delight in the season. Here, the author takes the reader through the Provence of her childhood and, backed by her original artwork, re-creates scenes and symbols of Advent that teach lessons. She skillfully invites her readers to put themselves into their own Advent story and gives practical advice on how to do exactly that. This is a book you will pull out year after year as you approach the Advent season."

Ruth Senter, author of *Longing for Love* and *Seasons of Friendship* and former editor of *Today's Christian Woman* and *Partnership Magazine*

"Advent is the most difficult season to spiritually inhabit: too many rich themes over too short a period with too much competition for our attention. And it all tilts toward cliché in the carols, the cards, the crèches. So I welcome this book with its fresh insights and simple practices that will deepen us as humans and enrich our communities. Rather than taking us back to the Palestine barn, it brings that familiar scene vividly to our homes and locales. Sylvie Vanhoozer animates our imaginations! She speaks of Wort and warts, warp and weft, work and wonder. She helps us artfully 'welcome Christ into our world whenever, wherever, and whatever we happen to be and be doing,' so that he can advent in us richly."

Bobby Gross, author of *Living the Christian Year*

"This beautiful book is a gift in every way. It is hard to experience waiting as a gift these days, but Sylvie Vanhoozer invites us to receive anew the gift of the Advent call to watch and wait. She helps us to experience waiting not as something we simply endure but as a hopeful gift we can receive in our particular times, places, and callings. As we engage with God's timeless word and Sylvie's thoughtful words, and as we reflect on her delightful art and act on her invitations to pray, ponder, pause, and play our part, we will learn to embrace the gift of living in Advent. This rich and inviting book is for all disciples who want to indwell the story of Christ right where they are. It is for all who long to embody an attentive, joyful posture of Advent anticipation all throughout the year."

Kristen Deede Johnson, dean and vice president of academic affairs and G.W. and Edna Haworth Chair of Educational Ministries and Leadership at Western Theological Seminary

SYLVIE VANHOOZER

The ART of LIVING in ADVENT

28 DAYS *of* JOYFUL WAITING

An imprint of InterVarsity Press
Downers Grove, Illinois

To Tom and Gay Harris,

the shepherds who accompanied me in my first

Advent Walk and showed me the entry to the manger.

InterVarsity Press
P.O. Box 1400 | Downers Grove, IL 60515-1426
ivpress.com | email@ivpress.com

©2025 by Sylvie Vanhoozer

All rights reserved. No part of this book may be reproduced in any form without written permission from InterVarsity Press.

InterVarsity Press® is the publishing division of InterVarsity Christian Fellowship/USA®. For more information, visit intervarsity.org.

Scripture quotations, unless otherwise noted, are from The Holy Bible, English Standard Version. ESV© Text Edition: 2016. Copyright © 2001 by Crossway Bibles, a publishing ministry of Good News Publishers. Used by permission. All rights reserved.

Scripture quotations marked MSG are taken from The Message, copyright © 1993, 2002, 2018 by Eugene H. Peterson. Used by permission of NavPress. All rights reserved. Represented by Tyndale House Publishers.

While any stories in this book are true, some names and identifying information may have been changed to protect the privacy of individuals.

Interior illustrations: Sylvie Vanhoozer

The publisher cannot verify the accuracy or functionality of website URLs used in this book beyond the date of publication.

Cover design: Faceout Studio, Tim Green
Interior design: Daniel van Loon
Cover images: Plant art by Sylvie Vanhoozer

ISBN 978-1-5140-1138-6 (print) | ISBN 978-1-5140-1139-3 (digital)

Printed Colombia ∞

Library of Congress Cataloging-in-Publication Data
A catalog record for this book is available from the Library of Congress.

CONTENTS

INTRODUCTION: AN ADVENT PARABLE FROM PROVENCE *1*

Advent Week One
The ART of JOYFUL WAITING in PLACE

1. GOD SETS THE STAGE ... *5*
2. THE CRÈCHE'S *TERROIR* *9*
3. THE ADVENT WALK .. *12*
4. THE WOMAN WITH OLIVES *15*
5. HOW I LEARNED TO BE ADVENTISH (PART 1) *18*
6. IN THE KITCHEN GARDEN *21*
7. PLACEMAKERS .. *24*

Advent Week Two
The ART of JOYFUL WAITING in TIME

8. THE TIMING OF ADVENT .. *26*
9. WHERE ARE YOU? .. *29*
10. IMAGINING OURSELVES IN THE NATIVITY STORY *32*
11. THE MUSICIAN .. *35*
12. HOW I LEARNED TO BE ADVENTISH (PART 2) *38*
13. LESSONS FROM LENTILS *41*
14. STORYTELLERS .. *44*

Advent Week Three
The ART of JOYFUL WAITING in SOLITUDE

15. God Is Ever and Everywhere Present 47
16. Seeking God in Solitude 50
17. Fear of Solitude.. 53
18. The Shepherd... 56
19. How I Learned to Be Adventish (Part 3) 59
20. At Table with God...................................... 62
21. Attendants ... 65

Advent Week Four
The ART of JOYFUL WAITING in COMPANY

22. God Gives Companions................................. 67
23. A Great Cloud of Companion Santons 71
24. A Company of Flawed Saints........................... 74
25. The Baker.. 77
26. How I Learned to Be Adventish (Part 4) 80
27. A Doughy Delight...................................... 83
28. Celebrants ... 86

Epilogue: Advent Away from the Manger 89
Acknowledgments... 91
Notes .. 93

Introduction

AN ADVENT PARABLE
from PROVENCE

The best thing you can do for your fellow, next to rousing his conscience, is—not to give him things to think about, but to wake things up that are in him; or say, to make him think things for himself.

GEORGE MACDONALD, *A DISH OF ORTS*

This book introduces you to a place where, for centuries, the people have sited the manger in their own land in a way that suggests Jesus has come, is coming, and will come to their own place and time. I invite you to enter into their nineteenth-century story, a parable of the kingdom of God, and make it your own. But there is no need to travel to southern France, much less to Bethlehem. You can meet the central character of Advent in your own time and place. In fact, doing so is what Advent is all about.

This story in that other land will transport you to a world of possibilities and, as George MacDonald says, awaken you to things in your own place. This is a book for disciples who want, watch for, and

wait for Christ to come into their own life stories. It is an invitation to see Advent happening not only *there and then,* but *here and now.*

It all started for me when I was very young, through my childhood Christmases in Provence. I watched the *crèche* come into its own year after year, with each new Advent. I remember my mother, herself a Provençal villager, taking the *santons* out of their box, calling each figure by name, lovingly. Placing these santons ("little saints" in the original language of Provence where this custom originated), colorfully painted three-inch-high little clay figurines, was second nature (or nurture) to her. She seemed to know them, and their stories, as well as those of her own family. The baby Jesus, of whom I knew next to nothing at the time, was there too, in a manger that looked just like the typical stables of Provence with which I was familiar.

As Maman hummed the *noëls* (Provençal carols) that told stories about Jesus, and the little clay figurines, I supposed they were all simply characters from folklore and legend. Yet, I also had a vague sense, and hope, that maybe something might very well have happened, that this baby Jesus, the center of attention in the manger, really might have come to Provence and, in so doing, somehow made us and our land extraordinary, even holy. Did Jesus come to us, or did we come to him? Was Provence special because its people had made room for the baby in the manger?

Such thoughts lingered in my imagination through the years of my tender childhood. I often found myself thinking of that baby, and of the stories about these villagers—the little saints—supposedly undertaking a nightlong search for him. I was not "churched." I had never opened, or even seen, a Bible, or listened to Bible stories. Nevertheless,

the crèche was sowing seeds in my mind and heart, as it still does each Advent in every home where the scenes prior to Jesus' birth are set up and played out.

This is why I am still telling the stories that I first heard one Advent, a long time ago, in a faraway place: "the land of my ancestors." People may wonder: Is Provence truly special, or is she embellishing or romanticizing it? And if it is special, should I move there and live among its people? I am not inviting readers to leave their place and go to some distant land in a distant past. The invitation is rather to transpose this Provençal scene into one's own place, to live the same story in a different context. The invitation is to learn the art of watchful waiting for Christ anywhere and anytime: "One might have to invent a new *art de vivre* (art of living), one that is not a copy of the past but, in a new context, a return to the values behind it, that made this past worthy." *Précisément!* The question is not "Did Jesus really come to Provence?" but rather "Could Jesus really come here, to me?" Could my home, my neighborhood, my church, become a crèche scene, with Christ right here beside me, *in* me? Come and see!

I invite you to slow down as you read this book, to reimagine the Christmas holidays as Advent holy-days. Think of Advent not as a door one passes through to something more exciting but as a *tableau vivant* or "living picture," into which one enters, a series of scenes from another time and place, where people live at a gentler pace. These scenes of santons, and of the botanical world that God gives us, invite both attention and reflection. The tableau is composed of four scenes, one for each week, in which you will watchfully wait for God's presence and activity—in your place, in your stories, in solitude, and

in company, respectively. The seven days of each week have prayers, questions, and projects that encourage you to practice the art of living in Advent. Think of them as spiritual exercises for becoming adventish: the quality of a person who knows how to watch and wait with joy, with expectant faith in Jesus' presence and activity, regardless of the circumstances. As you read, then, "Be still before the LORD and wait patiently for him" (Psalm 37:7).

My hope and prayer is that by the time you finish reflecting on these scenes, you will step into a world that has been not simply re-enchanted, but charged with the grandeur of God, a world in which you do not simply observe the manger scene and its characters at a distance, but see yourself as part of that same story, not a static figure but a *live* character. I hope you will come to see yourself as not a little but an *everyday* saint, embarked on a pilgrimage through spaces and times made holy thanks to the advent of Christ in you. The art of joyful waiting involves learning not to bide one's time until something exciting happens but, rather, to *stand by*, alert for opportunities to welcome and join the one who is always/already there to welcome us, even when his presence and activity are not visibly obvious. This book may start in Provence, but it ends in your own neighborhood.

So step into this Advent parable and join with other saints as, together, we learn the art of living in Advent, perchance to awaken a world of possibilities for joyfully welcoming Christ into our midst!

Advent Week One
The ART of JOYFUL WAITING in PLACE

Day One

GOD SETS *the* STAGE

O Bethlehem ... from you shall come forth for
me one who is to be ruler in Israel.

MICAH 5:2

During the four hundred years of what we could call Israel's long Advent season, the people of God waited for their Messiah, Immanuel (Isaiah 7:14), to come to a very specific location: "O Bethlehem ... from you shall come forth for me one who is to be ruler in Israel." To Bethlehem we must then look!

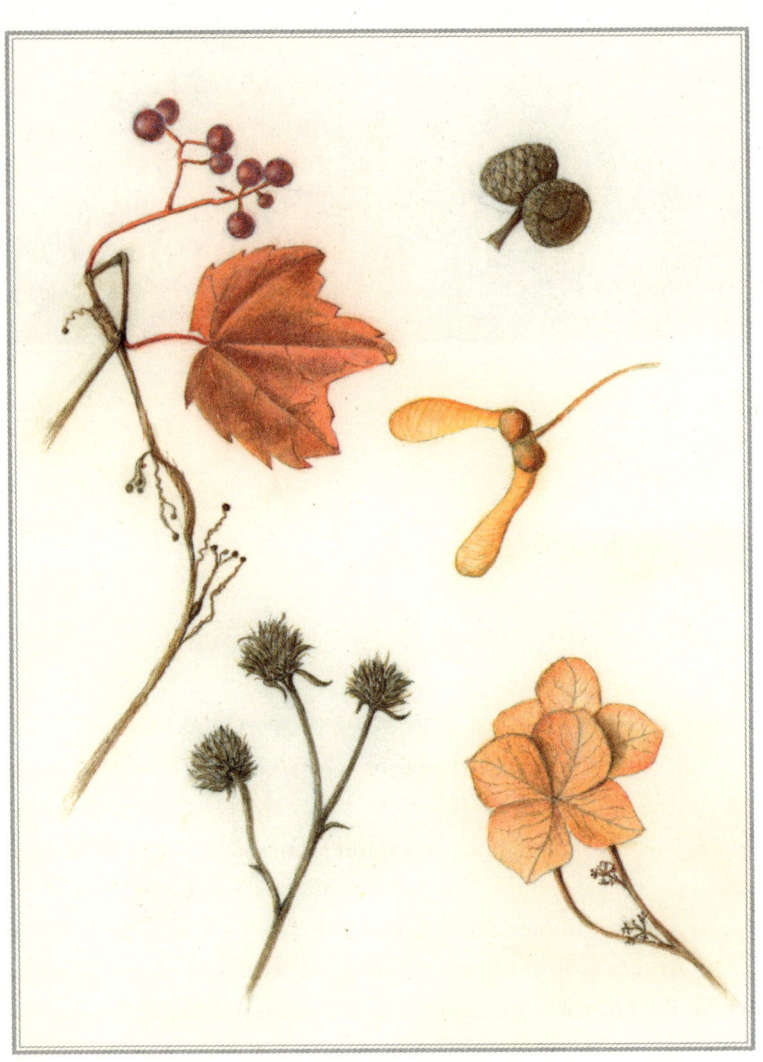

Seasonal local vegetation

This is why my ancestors called their nativity scenes *lou Belèn*: "the Bethlehem," in Provençal. But this "Bethlehem" looks strangely like home, not just because of its name but, even more conspicuously, because of its architecture and landscaping. With its red-tiled roofs (*les tuiles romaines*) and plants such as thyme, juniper, and rosemary, it practically shouts out its Provençal roots. Another hint as to its southern French location are the clothes worn by the little clay figures who fill out the scene. These santons ("little saints") bear a striking resemblance to the people who lived in the scattered villages of Provence in the early nineteenth century, when these unique manger scenes first appeared.

In a garden far, far away from the Mediterranean—my present home a few miles from Lake Michigan—I look for seasonal vegetation, in *my* local place, with which to decorate my own crèche. This is what I would be doing to welcome him if I still lived in Provence. However, as one of the stepping stones in my garden proclaims: *I am here*. And *here* is the place where I am weaving my new homeland, with its distinct plants, onto an old tradition, itself woven onto the greater story of what first happened in Bethlehem, when the long-awaited Messiah came to us, in the flesh (John 1:14). From wild vine leaves slowly changing into dark umber tones, to delicate hydrangea flowers, I seek treasures. It is but one of the many gardens God has created—not the first (Eden), nor the one I knew as a child in Provence. Rather, it belongs to the place where I now am. *Here* is where I am learning the art of watchful joyful waiting. *Here*, too, is where the Lord continues to come.

Pray

Lord, thank you for all the gardens I have known, and for the garden you give me now, one more place where I can welcome you. Thank you for your Son, who came as second Adam to a particular place on earth, Bethlehem, to dwell among us in a new way and show us the way back to you. Help me to watch patiently and faithfully for your presence and activity wherever I am. Even in this pre-winter season, when nature seems to be dying, help me see glimpses of life in your garden!

Day Two

The CRÈCHE'S *TERROIR*

"For unto you is born this day in the city of David a Savior, who is Christ the Lord."

Luke 2:11

In the beginning of Advent the sons and daughters of Adam in Provence busy themselves around the cradle, not of civilization, West of Eden, but of the child Christ. In the land of my ancestors, the tradition is to relocate the hallowed manger, the place where the Son of God came to earth, in their own land, their *terroir*. The word terroir is more poetic than *territory*; it refers to the peculiar soil of a particular locale that grows a specific vegetation and, eventually, a distinctive people. *Le terroir, c'est nous* ("The land, it's us"). Their place is tied up with their identity and sense of belonging.

The tradition of rooting Jesus' manger in Provence is legendary but nevertheless symbolic, an expression of faith: Jesus has come to our land, along the shores of a vast blue sea and the banks of the Rhône river. Jesus has come *to us*. The crèche grafts their story onto Jesus' story, not by replicating a first-century Palestinian stable in

present-day Provence, but by transforming the first-century Palestinian manger into a nineteenth-century Provençal crèche. Why the anachronism? Because "the Word became flesh and *dwelt among us*"—or, as *The Message* puts it, "moved into the neighborhood" (John 1:14, emphasis mine). What the crèche lacks in historical accuracy it more than makes up for in theological correctness: "For to *us* a child is born, to *us* a son is given" (Isaiah 9:6, emphasis mine)!

To the crèche makers of Provence, this anachronism relocates the greater story, and the baby Jesus himself, into the midst of their own land and traditions. From intimate living rooms to marketplaces, museums, and city halls, the scene represents in miniature the beginning of the story of Jesus—here. Whether or not they believe in him as Lord and Savior, he is part of their land, and their land is part of his story! Surely this is something to ponder in one's heart, as I did when I was very young, even though I, like other children from a nonreligious home, never quite knew what happened to the baby Jesus when he grew up!

This tradition of situating the manger, baby and all, in our own environs has become ingrained throughout southern France. If it is true that "There is not a square inch in the whole domain of our human existence over which Christ . . . does not cry, 'Mine!'" then surely he can visit his followers, wherever they happen to be—Provence, like my ancestors, just as well as Nigeria, Haiti, Indonesia, or any other locale. Jesus can come to any people group and culture, as the pouring out of his Spirit at Pentecost shows us (Acts 2:6-17). The historical facts of Jesus' birth in Bethlehem are important: they fulfill prophecy and display the faithfulness of God. But Advent is not

just about reenacting the past. Nor is it only about anticipating the future—the *second* coming of our King. No, for everyday disciples the world over, Advent is also very much about the present. It is about learning how to watchfully wait for Jesus in my place. Should we not welcome and invite him in?

Pause

Consider situating the manger in your place this Advent. Think of it not as a scene to look at *but one to* step into, *an opportunity to rethink the meaning of Christmas, to remember that God puts us in places into which we can invite him to come. Thank God for your place and for his presence there!*

Consider, too, that as we are watching and waiting for Jesus, he is watching and waiting for us, not in church on Sundays only but in all our times and place. Jesus is even now moving "into the neighborhood."

Day Three

The ADVENT WALK

*So he built the house and finished it, and he made the
ceiling of the house of beams and planks of cedar.*

1 KINGS 6:9

*I*n order to set the greater story in their land, crèche keepers of Provence established a practice that remains dear to them. On the first weekend of Advent, they engage in *la promenade de l'Avent* ("the Advent Walk"). It has become a kind of sacred pilgrimage. Alone or with extended families, people climb hills, follow country paths, and gather from the surrounding land whatever native vegetation might be good to use for decorating the crèche, the better to welcome Jesus to *their* terroir. In the land of my ancestors, the crèche is not complete unless and until it is decked out with local décor. As a result, the manger scene looks uncannily like their surrounding hills, covered with pines, olive trees, and ancient oaks. There, the earth exudes the scents of thyme, lavender, and rosemary.

The material scenery in the manger is a visual aid to an important spiritual truth. In response to *his* coming to us, we come to him, in a

way that symbolically roots the one through whom all things were made (John 1:3) in the particular patch of earth he has created and given us. For families with children in tow, the Advent Walk is a rich opportunity to revisit both their earthly home and the story of the one to whom it ultimately belongs. As Sharon Lovejoy says, "Remember always that your child's knowledge will spring from the roots you planted deeply in the fertile soil of wonder." The Advent Walk itself can be that soil of wonder, an opportunity to awaken in adults and children alike an imagination that discovers a great wonder in the heart of the natural world: God with us, in our very place!

When the amblers return home from their Advent Walk, they place their botanical treasures in the miniature scene, adorning the manger. By squinting just a bit, they see sprigs of thyme in the crèche as miniature olive and almond trees. By crushing herbs from the hills between their fingers every few days or so, they keep fresh the scene that now includes familiar outdoor scents. Thanks in part to the Advent Walk, our place—its sights, shrubs, and smells—is caught up in the story of Jesus. And when Jesus is present, our everyday places become special: "Take your sandals off your feet, for the place on which you are standing is holy ground" (Exodus 3:5).

To those with eyes to see (and noses to smell), the locally bedecked manger, with thyme and lavender rather than with cedar planks as in the temple of old, becomes a tangible invitation to join his story. The crèche, with the Christ child at the center, is his way into our world, and our entryway into his. Let us therefore watch and wait, with heightened senses, for signs that the Son of Man is indeed making his home with us.

Play Your Part

The Bible mentions many plants by name, even some common to Provence, such as climbing vines, olives, and oak trees. Do you know your place and the plants that belong to it? Can you learn more about the plants in your area, as I had to do in painting mine, whether you own a crèche or not? Consider starting a botanical journal. Do you see how this might help you to welcome the child Christ in your place?

Remember you belong to a greater story that nevertheless includes you, as it does the trees and plants that belong to your place, for "the earth is the Lord's and the fullness thereof" (Psalm 24:1).

There is something to learn outdoors about life, its seasons and rhythms. There is a lesson even in the falling leaves about the impermanence of natural life, and in dormant seeds about the promise of eternal life in Christ. Practice the art of watchful waiting for the Lord of the leaves and life!

Day Four

The WOMAN with OLIVES

And the dove came back to him in the evening, and behold, in her mouth was a freshly plucked olive leaf.

GENESIS 8:11

Once the crèche is decked with local vegetation, its keepers add to the makeshift farmhouse the little terracotta figurines, the santons that inhabit it. Though they're called little saints, none belong to a religious order. They actually represent all walks of life, and in the nativity scene they are busy pursuing their everyday occupations. It is this ordinary work that produces the gifts they will eventually bring to the Lord of the land—the land which he gave them in the first place, with its lavender fields, vineyards, and olive groves. The crèche is thus a beautiful picture of giving and receiving: the gifts they bring to the baby Jesus all come from their land, the same terroir that has cultivated them. Moreover, the santons themselves come—literally!—from this same land, made of local clay from Marseille and Aubagne.

The woman who brings a basket of olives to Jesus is just one of this great company of land cultivators. As it happens, the period for olive

harvest falls sometime (depending on the weather) between November and January—Advent season!

The olive woman's figurine carries the comb with which she harvests, reminding everyday saints of the inseparable link between nature and our creation mandate (Genesis 1:28). When God told Adam to work and keep the land, and to eat all that grows out of it (Genesis 2:15-16), he ordained his creatures ethnobotanists. For people and plants, and therefore the land that grows and sustains both, were meant to work together, under God, for good.

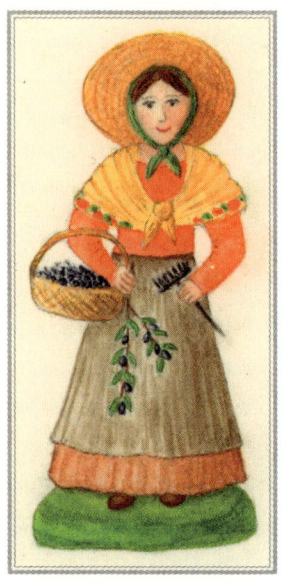

The woman with olives

There are many stories of olive branches, trees, and oil in Scripture and in ancient Greece and Rome, where the olive branch was a symbol of peace. Provence, so named because it was once a Roman province, is no exception. The presence of the olive woman in the nativity scene grafts the ancient stories of her land and its produce onto the even more ancient story of the Word who, before he became flesh, spoke the world, together with its fields of olive trees, into being. The olive branch also brings to mind the story of Noah, whose ark, itself a kind of cradle (1 Peter 3:20), brought the promise of a new beginning, heralded, even before the rainbow, by an olive branch that signaled the end of Noah's watchful waiting for dry land (Genesis 8:11).

Everyday saints continue to watch and wait for olive branches—signs of the peace that follows floods, fears, and wars. We watch and wait with the rest of the family of God in our makeshift arks, local churches, Advent cradle on board. We watch and wait by open windows for the dove to return with a freshly plucked olive leaf. We watch and wait with open hearts for the Christ child—the ultimate olive branch—to come and enter in.

Ponder

Could it be that, as Jesus enters in, he restores right relationship not only with the Lord but also with the garden that was cursed with thorns and thistles as a result of the fall (Genesis 3:17-18)? Should everyday saints return to their original vocation and become ethnobotanists, place makers, and peace bringers?

Consider what it might mean to be a "theo-ethnobotanist," one who places the Lord God at the center of our relationship to the land he gave us. Could the woman with olives be such a one? Could we, like this santon, bring, or perhaps be, olive branches in our particular places?

Day Five

HOW I LEARNED *to* BE ADVENTISH (Part 1)

His invisible attributes, namely, his eternal power and divine nature, have been clearly perceived, ever since the creation of the world, in the things that have been made.

Romans 1:20

Some years ago, I found myself, all grown up, once again in the village of my ancestors, just before Advent. As I stood in the cemetery, amid age-old vineyards with a view of Mont Ventoux in the distant mist, I felt a deep longing to walk the hills as I once did, to gather myself and enter into the quiet of the season. The hush of nature enfolded me, calming my mind, heart, and soul as I contemplated my new season ahead, a newly fatherless child with weakening roots to the beloved land of her ancestors. I understood, more clearly than ever before, the wisdom of the early church fathers who chose to "plant" the season of Advent at just this point in the calendar: a time when the tender hues of the land, the soft glow of the sky, and the earthy tones of the bare tree limbs bid us to enter, with them, into a

time of rest, while quietly hoping in the new growth to come. Advent is the season that invites us to be still and know that God is God—and that God has come to us.

I also understood that the Advent Walk has more than vegetation to offer: a way of being in the world. I had, of course, walked these same paths many times before, sometimes on my own, often with companions, and most memorably, with two energetic little girls running eagerly from one treasure (a pinecone) to the next (a snail shell). Even my daughters, though excited, felt the quiet within harmonize with the quiet without: they whispered to each other in respectful voices, awestruck at the natural wonders on the forest floor. It was an Advent Walk I shall always remember, filled with excited whispers and eager expectations.

Over the years and across the miles, I continue to make the Advent Walk, far from Provence. I now trim my crèche with plants from whatever place I happen to be. The plants don't have to come from Provence, as I once thought. This realization marked a major shift in my thinking about the pilgrimage that is my Christian life. These days, I watch and wait for Jesus to come to *my* place, here and now. My Advent Walk helps me perceive his invisible attributes in the things that have been made *here*, like wild vines and prairie seedheads. Immanuel: "God with us." That means *here* too—thanks be to God!

My Advent Walk has become something of a permanent fixture, spreading out like the roots of an old oak. My daily walk with the Lord has become a yearlong Advent Walk; I am watching and waiting expectantly for signs of God's presence and activity at every moment and in every place. The seasons of nature and life may, and do, change, but God remains faithful, ever present, not only in the manger but in every

place. Observing Advent helps us become skilled in watching and waiting for Christ's presence and activity in every place. I've come to regard Advent as the special season in which I re-learn how to be adventish in all seasons and places: the *Belèn* (Bethlehem manger) can be right here, right now!

Ponder

Some of us do not have a hill, country path, or forest preserve in which to roam. Can you find some small patch of earth away from the business district: a landscaped neighborhood, a church garden, a city park? Or if you have a backyard, can you invite someone who does not have access to nature to enjoy and glean Advent treasures from your terroir? Can you walk with someone beside still waters or bright flowers, restoring their soul?

Some santons are not able to walk. They sit instead. They remind us that the Christian life, the real pilgrimage, is an affair not of the legs but of the heart. They can still be attentive to what is around them. Can you find ways to help others practice being adventish, to watch and wait in joy, knowing that Jesus can walk through walls and soften hearts to get to us?

Day Six

In the KITCHEN GARDEN

*And out of the ground the L<small>ORD</small> God made to spring up
every tree that is pleasant to the sight and good for food.*

G<small>ENESIS</small> 2:9

*I*n my kitchen there hangs a poster with color pictures of familiar objects from my part of the world. It's called "Saveurs de Provence" ("A Taste of Provence"). There are photographs of everything that typically grows in the terroir. Olives feature prominently: there is an olive branch, jars of olives marinating in herbs from the hills, bottles of olive oil, even *savons de Marseille* (soaps from Marseille), guaranteed to contain 72 percent olive oil.

Yet, oddly enough, squeezed in between a pot of thyme and a jar of rosemary-infused oil are two brightly painted santons. Evidently, these little saints are as much part of the "flavors" of Provence as the figs, thyme, and lavender honey that are clearly products of the land.

I like to think my kitchen poster represents something deeper than tourist souvenirs of a brief visit to Provence. I like to think these nativity figures truly belong to the place from which they've sprung.

They are reminders of the vital ethnobotanical relationship between people and plants, thanks to which raw materials (like olives) get transformed into processed goods (like olive oil, *vinaigrette*, or *tapenade*) in ways that promote human flourishing. The santons remind us of our organic connections to the land: they, like our plants, come from the earth—the clay from Provence—as Adam came from the earth (*adamah*), formed "of dust from the ground" (Genesis 2:7). These terracotta figurines also remind us of the babe in the manger; there would be no santons if there were no crèche for them to inhabit!

Nativity figures like the woman with olives remind us that God is the Creator of all good things, including the olive trees of Provence! Olives belong to the land; they pervade its culture and cuisine. Everyday saints elsewhere do well to become familiar with their own places, and with how to use its produce, when possible, to bring their own offerings to Jesus, the Lord of every farm and table. And as we bring local produce to our tables, remember that our kitchen tables can also become communion tables, places where we give our household not only a taste of our local regions but a foretaste of heaven. For our land, like that of the woman with olives, is the place where we are called to "earth" Jesus, to root his life in us right where we are. Could we too be pictured on a poster that gives viewers a taste of our local region, a taste of heaven on our patch of earth, and at our tables?

❧ *Play Your Part* ❧

Do you know what produce grows in your land? If you had a poster like mine in your kitchen, do you know what would be on it? Can you make a meal with at least some of your local land's produce? Might it help you

feel more connected to the Creator of your garden while working at the kitchen counter and feasting at the dining room table? Commit to trying, with your family or a small group of friends.

On your poster, which santon would you be? What might you do to be the "flavor" of your local place, an example of how to steward local gifts to nourish others and glorify our Creator?

Day Seven

PLACEMAKERS

"Be fruitful and multiply and fill the earth."

Genesis 1:28

In this season of Advent, when in nature the plants are gently fading away, the earth remains the Lord's—a theater to watch and wait for his presence and activity. Let us therefore not be too quick in running away from it, sheltering indoors out of boredom or fear of its apparent lack of life. The earth, and what grows on and out of it, remains a place to wait and see the goodness of God. Advent is a time to reflect on the mortal stage to which he invites us by calling us into existence, the same stage on which we invite him back. When everyday saints inhabit their local place with adventishness, the Lord may move into the neighborhood yet again (John 1:14 MSG). When that happens, nature's stage becomes a stage of supernatural operations.

For the everyday saint who practices the art of living in Advent, outdoor contemplation provides more than physical or mental exercise. Reflecting on nature exercises the imagination, a means of recalling the greater story to which we belong that started in a garden,

the place where God first began to cultivate his own purpose for the world, to create a suitable place and people where God's name could dwell (Deuteronomy 16:2). Theologian Lydia Jaeger puts it this way: "Creation provides the framework in which to understand salvation, which is essentially the re-creation of what sin has marred." To stage the nativity scene in our local place is to remember that we are a part of the ongoing drama of creation, fall, and redemption.

Advent is a time for everyday saints to pause and ponder ways to reclaim the roles of local placemaking creatures we were originally called to be. After all, *placemaking* is our prime directive: "fill the earth and subdue it" (Genesis 1:28). God created us vice-regents, representatives of his heavenly rule in our earthly place. When we live up to our vocation and offer up the fruit of the earth and our labors to the Christ child, we will not simply discover signs of God's presence and activity, we shall *be* the signs of the presence and activity of the Lord himself, right where we are: a grain of celestial seasoning on earth.

Pray

Lord, thank you for the gift of place on earth and the privilege of being a placemaker. Help me to see my locale as a place I can dedicate to your service, a place to watch and wait for you, a place to meet you! Thank you for loving me so much that you came to find me where I was and continue to come to me every day, just as and where I am.

May I live in such a way as to be included among the trees and the fruits and the scents of the land that Jesus spoke into being! Help me to be and give a taste of heaven in my place on earth!

Advent Week Two

The ART of JOYFUL WAITING in TIME

Day Eight

The TIMING of ADVENT

*"I am the Alpha and the Omega, the first and
the last, the beginning and the end."*

REVELATION 22:13

Just as the crèche invites us to participate in the place of Jesus' advent, the church calendar also invites us in its unfolding, weaving our days into the story of Jesus' birth and its aftermath, our lifetimes into his. The church year begins, at Advent, with the poignant reminder that God's people have been watching faithfully for salvation

since the very first hint of Christ's coming deliverance, in Eden, when God told the serpent that the woman's offspring would crush his head (Genesis 3:15 NIV). In Advent, we enter into the beginning of the fullness of time (Galatians 4:4).

In the fullness of time, God sent forth his Son, and the Word became flesh. My Advent art depicts another word of God, Saint John's *wort* (German for *word*), also known as Hypericum, a species that exists all over the world. At this time of year, vivid red berries replace summer's bright yellow blooms. Like the little saints who follow Jesus, it can grow almost anywhere. The ancient Celts believed that it could ward off evil spirits. It has also been used by herbalists to treat depression.

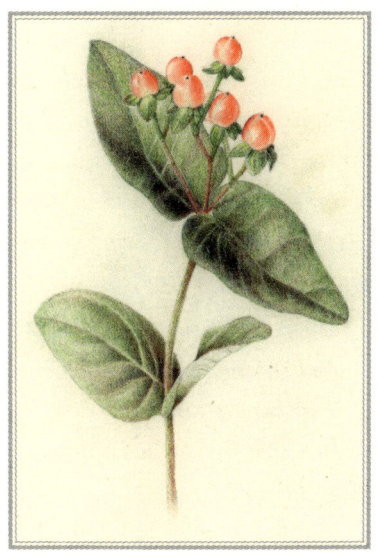

Saint John's wort

The gospel is good news because it proclaims a *wort* that really conquers evil spirits and treats depression, turning our mourning into dancing (Psalm 30:11). As John's Gospel opens the story of this Word who became flesh "in the beginning" (John 1:2), so the last *wort* of Saint John, the book of Revelation, describes how this same Word identifies himself as "the Alpha and the Omega, the first and the last, the beginning and the end" (Revelation 22:13). The nativity scene

takes place mid-story, but it recounts the birth of the one who is in truth the beginning and end of all stories. His Advent, just one chapter of this centuries-long narrative, is a clue to the meaning of the whole and an invitation to take part in it as followers.

Pray

Sing, hum, or read this Advent carol, and carry it in your heart all this week, like a prayer, as you recall how long Israel had to watch and wait for her Messiah King, Jesus: the wort *of God who finally broke the silence, the balm of Gilead who came to heal all wounds. The carol has accompanied generations of waiting people since its eighth-century monastic composition.*

O come, O come, Emmanuel.
And ransom captive Israel,
That mourns in lonely exile here,
Until the Son of God appear.

Lord, help me to hang on to the promise of your coming salvation, the promise to destroy sin, evil, and death itself. Help me to experience Advent as a time of joyful expectation of deliverance. I hope; help my hopelessness!

Day Nine

WHERE ARE YOU?

*But the L<small>ORD</small> God called to the man and said
to him, "Where are you?"*

G<small>ENESIS</small> 3:9

*I*n the land of my ancestors, we have another way to create a realistic manger scene, one that obliges us to enter Advent at a slower pace and reminds us that the Word who became flesh in Bethlehem has visited us as well. We too are "extras" in Jesus' nativity story. His story is the story both of our waiting for God and God's waiting for the right time, a ripe time in which time past, time future, and time present are all caught up in Advent's collective inhale, a hushed breath-holding as we wait to see what happens next.

Here is what we do. We take a large sheet of brown paper and crinkle it up in our hands, instantly creating a makeshift hill to place behind the manger. Its gentle creases create the impression of rough paths in distant hills. Then we place a few tailor-made santons (one inch rather than the regular three inches high) on the paths, far off in the distance, not yet here. These distant santons include the pregnant figure of Mary on a donkey, with Joseph by her side.

Why keep things to scale? Because it is ultimately about keeping time. To see Mary in the distance reminds us that the holy family is coming but not yet arrived at the manger. We are in Advent, when donkeys and kings and, most importantly, the babe are still "to come" (the literal translation of the Latin *ad* + *venire*). In Advent, Jesus is not yet Emmanuel, "God with us." The santons come in different sizes precisely for the sake of creating this depth perspective. The distance in space and time of the holy family from the manger represents the length of Mary's pilgrimage—and of ours.

Are we there yet? *Non!* Preparing the manger scene during Advent season helps crèche keepers to learn to wait, patiently yet joyfully, because we know the Savior has come, will come again, and continues to come even now, and not only in our hour of need. We can therefore slow down and savor the season. The art of living in Advent is all about cultivating this sense of confident expectancy: Christ *is* coming, but he cannot be rushed.

Advent, we have seen, is an integral part of a greater story when things happen at just the right time: "But when the fullness of time had come, God sent forth his Son, born of woman, born under the law, to redeem those who were under the law" (Galatians 4:4-5). We now have to wait for salvation because Adam failed to show up when the Lord of the garden was waiting for him, in the cool of the day: "Where are you?" (Genesis 3:9).

This question (*Where are you?*) echoes through the centuries-long story of Israel when the chosen people repeatedly failed to wait on the Lord. As a result, they had to endure the four hundred years of silence between Malachi, the last book of the Old Testament, and the angel

Gabriel's appearance to Zechariah, the father of John the Baptist (Luke 1:11-17), the last of the prophets, who proclaimed the arrival of the one who was to come.

Everyday saints must be on the alert, ever ready to respond to Jesus when he calls: "Where are you?" We do not want to miss the coming of our King! In an age that caters to instant gratification, keeping the baby out of the crèche until the right time helps me learn the difficult art of patient yet joyful waiting for Jesus' coming. Be assured: God's gift is worth waiting for!

Pause

Take a moment and reflect on how many times, and how long, God has had to wait for his human creatures to respond to his call: "Where are you, [your name here]?" How will you respond? Can you respond like Samuel? "Here I am!" (1 Samuel 3:4).

If you or your church has a manger scene, can you consider keeping the main characters back until the right time? Can you observe this discipline in order to indwell Advent and learn the art of joyful waiting? Can you learn to wait by collecting local vegetation to spread around the manger, rather than inserting the holy family too soon?

Try to attend, or watch livestream, a festival of lessons and carols (alone or, preferably, with a small group; make it an event). This traditional service, with its nine Scripture lessons, is a wonderful way to remember that Advent is part of a much longer story that begins in Eden, climaxes with the arrival of our Savior, and ends with Jesus' second Advent.

Day Ten

IMAGINING OURSELVES
in the NATIVITY STORY

*"Behold, I am the servant of the Lord; let it
be to me according to your word."*

LUKE 1:38

The nativity figurines in Provence also have a long history, hearkening back to much older Christmas pageants. Like the stained glass in medieval cathedrals, the medieval nativity plays were a way of helping laypeople visualize and imaginatively indwell the story of the Bible. These nativity plays were the origin of the *pastorales*, the traditional Provençal way of retelling (and enacting) the account of Jesus' birth. These pastorales inscribed familiar village figures—bakers, basket makers, town criers, and so on—into the nativity story.

Some of these traditional depictions add elaborate subplots and details about their characters, assigning them names, characteristics, even particular settings (e.g., a dispute with neighbors). These embellished stories are like parables of the kingdom that show how the coming of the Messiah might affect ordinary people. These vignettes

were often reenacted in front of churches from Advent through Epiphany for the people's entertainment and instruction. Think of them as life-size parables that helped everyday saints see how their own local affairs were part of a more important happening.

Fast-forward to the nineteenth century, when artists turned these "living mangers" into more permanent miniature scenes: the crèche and its santons. While most of the figures in these crèches offer up gifts from their own nineteenth-century vocations, some figures represent the well-known older characters in nativity stories handed down orally for centuries. The crèche tradition continues to this day and remains a compelling visual parable about the ways in which the lives of ordinary people can be woven into the greatest story ever told.

The santons are clearly rooted in the terroir of Provence: all the gifts they bring the baby Jesus have something to do with their locale, a place rich in soil, story, and song. Their significance is not only local, however, but universal. They continue to be role models every Advent to those who grasp their parable in miniature: these little saints show us how to *enter into* the reality of "God with us" with all we have and are, wherever we happen to come from or currently live. They show us how to come to Jesus "just as I am," how to continue coming to Jesus through all the seasons with the most precious gift of all: our everyday lives. They represent to me, and I hope to you as well, a standing challenge: How can I indwell the story of Christ in my place and time? What in my life can I make into a daily offering to my King?

Some months before the Christmas miracle, Mary came to understand that she had been chosen for a special part in God's plan to fulfill his ancient promise to King David to establish an eternal

kingdom (Luke 1:30-33). With a mature faith beyond her years, Mary quickly recognized to which story she belonged: this was not about her. This was about the living Lord coming to her, and hence to all the earth. No one else will ever play Mary's part again, but I wonder: What part have I been called to play? Am I watching and waiting for God's word to come to me? Can I too be a faithful follower and respond in obedience when God's word comes to me? Will I be able joyfully to repeat Mary's exemplary response: "Let it be to me according to your word"?

Ponder

Are you aware of God's greater overarching story? Do you ponder the things that happened in Advent and how they relate to you, as Mary treasured up and pondered them in her heart (Luke 2:19)? Can you imagine ways to make Jesus' story part of your everyday life the way my ancestors did with the crèche? Finally, have you pondered what I see as the wonderful exchange of Advent: how, when we invite Jesus into our lives and places, he invites us into his?

Day Eleven

The MUSICIAN

I will sing of the steadfast love of the LORD, forever; with my mouth I will make known your faithfulness to all generations.

PSALM 89:1

The featured santon is one of the many musicians in the traditional crèche. The hurdy-gurdy is the oldest instrument represented in the crèche and one of the most common at the time of the pastorales, the medieval Christmas plays, from which the santons originate.

The musician figurine pays tribute to the person without whom the santons might never have been: Nicolas Saboly (1614–1675). He was a choirmaster (*Maître de Chapelle*) in Avignon, where he composed or transcribed the many Christmas carols that, along with the pastorales, helped preserve the language and spirit of Provence. These familiar carols contributed to the feeling that the nativity story belonged in Provence. Many include the names of real villagers, such as Jeannette Isabelle, whose torch was inserted into a song about the King of kings!

The carols' lyrics add another layer of detail to the nativity scene and help us better imagine what it would be like to set out, in company

DAY ELEVEN

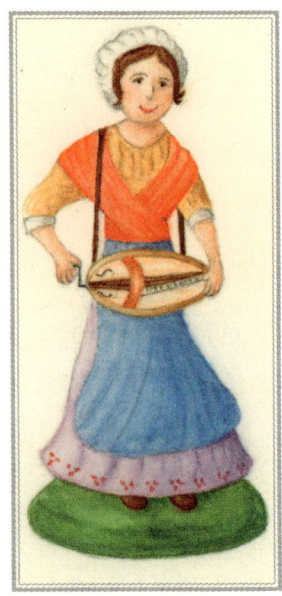

Woman with hurdy-gurdy

with other villagers, to come and adore the newborn King. Some characters worry about the dangers they might encounter along the way; others fret about what to take along ("Bring a torch, Jeannette Isabelle!").

Still, these carols unfailingly announce the good tidings, hence their name: *noël* (from Latin *natalis*, "related to birth"). They also root all everyday saint-singers in that greater story, not least because the lyrics situate the story of Jesus in our terroir, our culture, our history, as much as the olive trees, rosemary, and lavender. This is why there is a santon of a tambourine player among the other "flavors" on my "Taste of Provence" poster. It is another compelling image of Scripture's story absorbing the history and culture of a distant place and people.

Saboly "sang to the Lord a new song" and, in so doing, imagined a way of welcoming Jesus into his land and culture through the gift of music. He helped revitalize the feeble faith of the parishioners in seventeenth-century Avignon by making the Christmas story their own in memorable melodies and lyrics.

Long before Saboly, another bard also used song as he waited on the Lord. He played the lyre, not the hurdy-gurdy, and he composed psalms, not carols. King David used song to bring his everyday life—

his ups and his downs, fears and joys, desires and deliberations, victories and struggles—before the Lord. In so doing, he never lost sight of the greater story of which his life was but a brief though vital piece. He also invited others to join and sing with him on his way to Zion. Could he have been the very first caroler, I wonder?

I also wonder how I, with my own gifts, musical or not, can remind others that we belong to a story with glad tidings? How can I, with my simple gifts and my own culture, follow King David, and the santons, and "sing to the Lord" a new song with all I do and say, with the lyrics of my own life thrown into the mix? How can my life be a song for the Lord?

Ponder

Santon enthusiast Marie Mauron says that Saboly's vocation was similar to that of the Reformers who set the psalms to music. In both cases, the music spoke of all aspects of life in relation to the Lord. Could this be why Paul encourages the Colossians to sing psalms, hymns, and spiritual songs (Colossians 3:16)? Music is a gift we can offer to God that also helps us on our pilgrimage. You may not know the carols of Provence, but you have access to the psalms of David. Consider reading one psalm throughout the week. It could help you weave your daily life onto God's story. And if you know any set to music, follow the example of the hurdy-gurdy santon and add them to your Advent playlist!

Day Twelve

HOW I LEARNED *to* BE ADVENTISH (Part 2)

My frame was not hidden from you, when I was being made in secret, intricately woven in the depths of the earth.

Psalm 139:15

I once enrolled, with other high schoolers, in a weaving apprenticeship. It was there that I learned a life lesson (not part of the official curriculum) on the foundations of weaving—into the fabric of Christ!

The apprenticeship was in a remote farmhouse in the French Alps. Our instructors spent the entire first day teaching us the history and principles of weaving. We learned that there are two kinds of threads: the vertical one, called the warp, holds everything together; the other, called the weft, goes in and out horizontally, over and under the vertical threads, and creates the final picture or pattern. The warp must be kept taut with the help of a frame, the loom, on which everything hangs. There it was: Weaving 101.

We spent the next few days combing through the dormant woods for natural material with which to build our looms and then attaching

our warp on it. At the end of the week, most of us returned home with only an unfinished object. Nevertheless, I learned a simple-yet-potent lesson on that mountain: take all the time you need to build the solid foundation that supports the warp. The warp, you see, is indispensable. Without a properly stretched warp, attached firmly to the loom, I would not be able to weave the weft in and out and thereby create the picture for my wall hanging. There was nothing overtly spiritual about this workshop, but in hindsight I see a valuable lesson about what it means to be a disciple of Jesus Christ.

I have come to see the providence of God as the loom on which is suspended the meaning—the divine design—of life. The presence and activity of God's Word is the warp that sustains Israel's history, and my own life story. The art of living in Advent involves waiting for Christ to complete the emerging pattern. I marvel how, in hindsight, the various threads in the weft of my life have indeed formed a meaningful pattern. The woven picture of my life includes my gifts and skills, my childhood in and departure from Provence, as well as my placemaking efforts away from my native land. This woven pattern has helped me to make sense of my life. It has also inspired my writings about the santons. Contemplating this emerging pattern has given me great joy.

Advent is a season of apprenticeship, a four-week-long workshop in which one learns the art of watchfully waiting for the meaning of our lives to appear. It appears when we remember the foundational warp—Jesus Christ, the founder and perfecter of our faith (Hebrews 12:2)—that sustains our otherwise dangling threads. I want to weave my weft on the Lord's loom, the time and space I am given, so that the

threads of my life continue to entwine over and under, over and under Jesus, the warp of God. I want the final picture on the loom of my life to image Jesus.

Play Your Part

Advent is the season to watch and wait for patterns to emerge, in your own history as it came to pass in Israel's. Learn to see the events in your life as the weft that weaves over and under Christ, the warp of God—and watch the fabric of your faith grow strong.

Try to recount God's wonderful deeds, his advent in your own life, as the psalmist does. Meditate on Psalm 136. It is a spectacular way of looking at life, with God's steadfast loom holding all things together! Can you recount the ways where you have seen God's direction, where little things, including unexpected or painful ones, make sense in hindsight? Keep a journal and learn to marvel at God's warp underneath your life. Make it a daily practice. And remember that your story is woven onto the larger tapestry of what God is doing in our world. Remember that being adventish means joyfully watching and waiting for Jesus' advent to make sense of your life too.

Day Thirteen

LESSONS *from* LENTILS

And let us not grow weary of doing good, for in due season we will reap, if we do not give up. So then, as we have opportunity, let us do good to everyone, and especially to those who are of the household of faith.

GALATIANS 6:9-10

Once the *Provençaux* have brought out, decorated, and peopled their crèches, they engage in another unusual custom practiced for generations: they put lentils or wheat seeds in little saucers that, when sprouted, will go next to the crèche. There must be precisely three saucers, to represent the Trinity, a symbolic reminder that the baby lying in the manger belongs to a greater narrative that began "before the foundation of the world" (Ephesians 1:4). God the Father sends God the Son on a rescue mission, while God the Spirit is busy working in the little saints' hearts, prompting them to join the pilgrimage toward the manger to see the new thing God is doing in and for the world. Both the lentils and our coming to Christ (and becoming like him) take time. Those also follow who watch and wait.

Here is how the lentils work. First, spread a thin layer of cotton wool onto three matching saucers, then gently add a layer of seeds. Keep them damp (don't drown them!) and keep watch. A few days before Christmas, the grown shoots—now several inches tall—will need support. Tie a red or gold ribbon around them. Come Christmas Eve, you have a lovely little saucer of green shoots and bright ribbon, as festive as poinsettias. What joy!

I keep watch over my lentils (you can also use wheat) every Advent. As I wait for seeds to sprout, I ponder the ages-long work of God the Father, Son, and Holy Spirit—work that eventually sprouts, as it were, in the manger.

These grains have a special name: *le blé de l'espérance,* "wheat of hope," so named because French bakeries have woven a new thread into the story. In the 1980s, they began to sell kits with little bags of wheat to jog the memory of those who may have forgotten to prepare for Advent. The kits make good on the hope they symbolize: the sale price of two euros (just over two dollars) goes to local charities. Why? According to legend, it's because the custom of growing seeds in Advent began when villagers offered wheat to a poor family who had nothing to eat for the holidays.

As a homeless character in one of the traditional Provençal Christmas plays says, "Everybody should have turkey for Christmas." Indeed. Jesus says that whenever we give food to the hungry, we feed our Lord himself: "As you did it to one of the least of these my brothers, you did it to me" (Matthew 25:40).

As we learn to watch and wait for Jesus at Advent, he reminds us also to be *watching over* and *waiting on* others, especially "the least of

these." This is a particularly poignant yet appropriate way to welcome Jesus into our place. We can watch and wait on others not just by giving them bread—for "Man shall not live by bread alone" (Matthew 4:4)—but by lending a listening ear to a neighbor, speaking a gentle word to a coworker, or making a welcoming gesture to a stranger. Everyday saints must stay alert, watching and waiting for every opportunity to make the plan of salvation conceived before the foundation of the world present in every ordinary moment, becoming seeds of hope!

ᗅ *Play Your Part* ᗉ

We live in cultures that have forgotten how to wait for things—life itself!—to grow. Instead of being a time of preparation or joyful anticipation, waiting is often something modern men and women unhappily endure. The art of living in Advent has therefore become a lost art. Try the lentils experiment (or grow some other greens) and wait. Tell your guests its story!

Could it be that waiting on others is also a way of keeping watch, for him, and tending what he is trying to grow? Keep a lookout for other people too. There is always something to be done to tend what God is growing as we wait for Christ to come again. He will come at the right time. In the meantime, he has given us the gift of time—a time to grow lentils, a time to grow in the grace and knowledge of our Lord and Savior Jesus Christ (2 Peter 3:18), a time to serve others. Are you and your church watching out for others, waiting for opportunities to do unto them as we would do unto Jesus?

Day Fourteen

STORYTELLERS

But you are a chosen race, a royal priesthood, a holy nation, a people for his own possession, that you may proclaim the excellencies of him who called you out of darkness into his marvelous light.

1 Peter 2:9

At the end of the second week of Advent, Mary is still in the distant hills, still *expecting*, pondering in her heart the miracle of "God with us." So am I. For to set up the crèche, itself a reminder and display of Christ's advent, the promise of God made good, is to get caught up in and pass on the nativity story.

The santons de Provence came into existence when, following the French Revolution (1789), churches were not allowed to open their doors or teach about Jesus. Under this persecution, outdoor crèche displays were prohibited. However, devoted (and enterprising) Christians made miniature models of the crèche to set up in their homes—out of sight of the authorities but nevertheless a risky undertaking during what is now known as the Reign of Terror. Still, like the ancient Israelites who kept Passover in order to pass on the story of their

deliverance from bondage in Egypt, so these faithful Christians wanted to pass on the story of Jesus' Passion, and their deliverance from sin and death, to their children. After all, the story that ends with a cross begins in a manger.

At first, people made their crèches and the traditional characters (e.g., shepherds, wise men, holy family) with whatever materials they could find—even bread dough—until one day an artist, Jean-Louis Lagnel, made some little figures out of clay. Like Nicolas Saboly our songwriter, Lagnel added extra characters, using local villagers from his own time and place as models, representing them as going about their daily vocations, bringing the manger scene (literally!) closer to home. Over the years, these new characters and stories merged with traditional ones, once again inscribing the story of Jesus into the fabric of everyday life (and vice versa).

The early Christmas plays (pastorales), songs (noëls), and little saints (santons) were all teaching tools, audiovisual aids for showing how people just like you and me could belong to the story of Jesus. Think of the crèche, and the art of living in Advent, as a laboratory for Everyday Theology 101, an opportunity for people to experiment in discipleship, to imagine what it might look like to live daily in the joyful expectation that the Son of God could come here!

Indeed, I like to think that God *did* come to Provence when he gave the idea for the santons, carols, and noëls to Lagnel, Saboly, and others. As Jesus says, "If these [his disciples] were silent, the very stones would cry out" (Luke 19:40). So, too, in their own way do these santons, lumps of clay, cry out. These tiny figurines, taken from local soil and incorporated into ancient stories and songs, are witnesses: more wefts woven onto the warp of Jesus' story!

Nativity scenes—whether in churches, town squares, or homes—tell the great story simply by being what they are. My ancestors risked the guillotine for something as banal as making miniature mangers. And I wonder: What am I risking by bearing witness in my own time and place? Have I made my home, my neighborhood, my heart into a manger in which I can welcome Jesus, a place where he can lay down his sweet head, a place into which I can invite others to meet him, perchance to add a character and write a new chapter in his ongoing story?

Pray

Thank you, Lord, for this special season in which you invite me to slow down, to do nothing but watch and wait for you to do great things, to prepare to welcome you in the weft of my life. Help me to be an everyday saint who can show others what it looks like in ordinary life to be part of your extraordinary story, and proclaim the excellences of him, the light of the world, who has come to call us out of darkness. Help me be a real live santon, one who can tell the story of the light shining in the darkness not only with words but with my life.

Advent Week Three

The ART of JOYFUL WAITING in SOLITUDE

Day Fifteen

GOD IS EVER and EVERYWHERE PRESENT

Where shall I go from your Spirit? Or where shall I flee from your presence? . . . If I take the wings of the morning and dwell in the uttermost parts of the sea, even there your hand shall lead me, and your right hand shall hold me.

PSALM 139:7, 9-10

Advent is an opportunity to retreat from culture's rush—that frantic pre-Christmas scramble that can easily dominate our calendars—and, instead, enter into nature's hush, a seasonal quietude more conducive to attending to the God who is present, but perhaps hidden and forgotten amid the hustle and bustle.

A certain inner stillness may be required for understanding the mysteries of God hidden in creation. The ability to communicate to others the special presence of God that Advent celebrates—"God with us"; the miracle of God entering into human history—is essential if we are to witness God's design for creation "to a world impaired in its ability to listen." Might Advent be the special season that provides us time, and a place, to restore our impaired ability to listen to the living Lord himself, as we ponder his presence in nature and in our crèches?

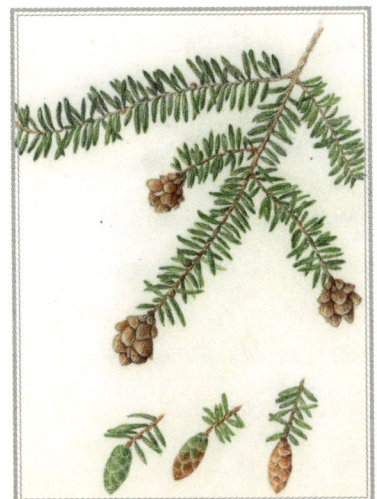

Hemlock

The evergreen trees we encounter on our Advent Walk and use to bedeck our mangers and homes during this special season symbolize the ever-presentness of God. Like our Lord, they are never-changing: even in the depths of winter, they remain *ever* green. It is altogether fitting, then, that we mark Jesus' birth, "God with us" in bodily form, by hanging greens. They remind us that God was with us not only

for the thirty-three years of Jesus' life, but that he is *ever* present with us.

The eastern hemlock, loved for its longevity and native to my current location, with its limbs of green needles and flowing sap, is a standing reminder that life can be found even in the winters of our discontent. The evergreen is a sign not only of Jesus' birth but of his constant presence in our lives, for the Spirit of Christ is our living sap, flowing through our limbs, its pinecones a sign of his fruits maturing in each season. Advent is a time imbued with the promise of life present, life to come, and life everlasting. The everlasting Lord has come, is here in Spirit, and will come again: Where would we flee from his presence? Why would we want to?

Lord, help me regain the ability to attend to your presence, to discipline myself to be still, knowing you are present, a source of everlasting life. Show me how to keep the life of Christ, like the sap in the hemlock tree, flowing in me throughout the day.

Day Sixteen

SEEKING GOD *in* SOLITUDE

"Come, let us go up to the mountain of the LORD . . . that he may teach us his ways and that we may walk in his paths."

ISAIAH 2:3

There is an age-old pastoral practice in Provence called *la transhumance*. The literal meaning is "cross-country," that is, going across (Latin *trans*) the ground (Latin *humus*). Transhumance refers to the seasonal change of grazing land, when herds of livestock leave behind their lower pastures and head for the hills (or vice versa).

In early summer, shepherds accompany their long procession of sheep across villages, vales, and dales, on their way to the hills, where the grass is green and fresh. Shepherds stay with and watch their sheep the whole season. Apart from the occasional food delivery, shepherds live in solitude, away from human interaction. During the weeks-long transit to the top, the villagers they pass observe their progress with celebrations, but also with awe and respect for these brave hearts who bid adieu to civilization and dwell in solitude for months at a time. Some think that shepherds must be endowed with a wisdom inaccessible to those down below.

Even now, various towns and villages in Provence reenact this custom of transhumance in Advent. It is one of the traditional fixtures in the land of my ancestors. Indeed, Advent observances get underway when inhabitants, often dressed like santons, line the roads and wait for the shepherds to arrive. Meanwhile, musicians play and sing noëls, usually (and fittingly) about the shepherds who return from the hills with a startling announcement of a visitation by angels. When the time comes, it is the shepherds, followed by the musicians, who lead the way and usher the villagers into Christmas.

The noëls recount what, according to the Gospel narrative, the shepherds saw and heard: "When the angels went away from them into heaven, the shepherds said to one another, 'Let us go over to Bethlehem and see this thing that has happened, which the Lord has made known to us'" (Luke 2:15). They leave for the mountains as shepherds; they return as men of God, prophets, with news which was in a very real sense "out of this world," for its origin was heralds from heaven. This may be one reason why an aura of mystery continually surrounds these shepherds.

Kallistos Ware describes those who never reach that mountaintop solitude, close to heaven, where it is easier to hear God: "We lack the power to gather ourselves into the one place where we should be—*here,* in the presence of God; we are unable to live fully in the only moment of time that truly exists—*now,* the immediate present." Not so the shepherds, who were fully present in their moment, the fullness of time!

We may wonder why the shepherds, in their watchful solitude, were the ones who saw the angels. Whatever the case, the shepherds'

example invites us to consider whether we too, shepherds or not, should undertake our own metaphorical transhumance and go somewhere secluded in order to receive the gift of solitude. It may require effort, not to walk uphill but to find a place away from the busyness of this season, where we can take time to listen to what God has to say to each of us this Advent, whether by angelic or another kind of messenger. Advent is an opportunity to rediscover the presence of God in the absence of distraction. Come, let us go up to the mountain of the Lord!

Pause

In the Bible, God things often happen to people on mountains in moments of solitude. Moses met the Lord alone on Mount Sinai; so did Elijah on Mount Horeb, and Jesus himself "went up on the mountain by himself to pray" (Matthew 14:23).

You may not have an actual mountain to ascend. (Living in the Midwest, I do not.) All you really need, however, is a remote place, and the discipline to be alone for a time, perchance to meet the Lord. Can you find a place, and a time, to listen and wait in the stillness of the season for the good news of Advent, for the startling announcement that "the Word became flesh and dwelt among us" (John 1:14)?

Day Seventeen

FEAR *of* SOLITUDE

*"Find a quiet, secluded place. . . . Just be there as simply
and honestly as you can manage. The focus will shift from
you to God, and you will begin to sense his grace."*

MATTHEW 6:6 (MSG)

The ancient noëls celebrate the watchfulness of the shepherds, who waited not only in joy but also in fear. In the traditional carols, the shepherds are sometimes scared as they undertake their nightlong pilgrimage to the Bethlehem manger. The carols speak of hunger, potential accidents, attacks by wolves, or ambushes by robbers looking to steal their sheep. And shepherds today readily admit that one of the hardest parts of the job, even perhaps more than the dangers of wolves or bears, is being alone for so long. Our shepherds, as human as the rest of us, feared solitude.

The motley company of pilgrims who, according to the folklore and carols, follow the shepherds to the manger are alternately hungry, thirsty, scared by noises, and generally distracted from their goal by one thing after another. They encounter so many adventures in these

stories that it seems their pilgrimage lasts much longer than one night; who knows, it might even be a lifelong pilgrimage! In one Advent play, while the pilgrims are making merry at a local pub at which they have temporarily halted, the angel Gabriel appears again and reaffirms what has happened. He reminds them what their pilgrimage is all about: going to the baby Jesus and welcoming him with their gifts.

The plays are comedies, and so we laugh. Yet I wonder if we laugh because we see ourselves in these distracted little saints. Don't I constantly make my little excuses for not keeping to the way? Don't I sometimes prefer the distractions to the solitude necessary for meeting with the Lord? Am I part of the motley company that veers off the road for a snack, a drink, the endless call of social media, a chat? Dietrich Bonhoeffer says, "We are so afraid of silence that we chase ourselves from one event to the next in order not to have to spend one moment alone with ourselves." How can I welcome Christ if I can't even remember he is the guest in our midst?

God things happen in Scripture to people who dare seek out secluded places in which to meet with the living Lord, who dare shut the door to all other voices in order to listen to him only. From Moses on a mountaintop and Peter on a rooftop to Paul in prison and John on Patmos, the people of God, by practicing this spiritual discipline of solitude, heard the voice of the Lord, and in turn became our shepherds who show their flocks, and us, the way.

The art of living in Advent may well begin with an awareness of what keeps us away from, and fearful of, spending time alone with God. Yet when an everyday saint does meet God in a secluded place—

surprise, one is no longer alone! The focus shifts from us to God, from aloneness to togetherness. Our fear turns into the joy of Advent.

⁂ *Play Your Part* ⁂

Once you have found your secluded place, ask God to show you which distractions are keeping you from seeking Christ. Advent is a time to practice being alone in silence, the better to enjoy a tête-à-tête with God. C. S. Lewis sees silence as what helps us listen to the voice of the living Lord, what keeps us from being dragged down to "the Kingdom of Noise," where our enemy awaits.

If you believe that you can and should meet him in silence and solitude, practice it today! Filling your mind and heart with him is what will chase the noise away! This too is how we welcome him! Wait and listen to what God places on your heart. Keep a list of what you hear.

Day Eighteen

The SHEPHERD

*Lead me in your truth and teach me, for
you are the God of my salvation.*

PSALM 25:5

The shepherd is the only "civilian" figure in traditional nativity scenes, belonging neither to the holy family, the heavenly host, or the company of exotic wise men. Because the Bible mentions shepherds as the first to receive the good news, however, they are an integral part of the crèche. Shepherds figure frequently in Provençal stories and carols, so much so that the traditional nativity plays have come to be known as *pastorales,* after the Provençal name for shepherds: *pastre.* Act one of these pastorales typically concerns their mysterious encounter with angels in the hills. Subsequent acts tell what happens next, from the perspective of the shepherds on their way to Bethlehem.

Most shepherd santons are depicted walking to the manger, but some are kneeling, or even lying down in the hills. Each posture communicates something to the onlooker. I like my standing shepherd,

who reminds me of a common idiom from Provence that refers to a person who is utterly useless: "Don't stand there like a santon. Do something!" Santons are inanimate clay figurines, after all; the idiom is therefore apt. Yet for us little saints who are *alive,* standing there, or otherwise remaining motionless, whether seated or kneeling, may be the best position to adopt before undertaking a pilgrimage. Be still, and know the God of the gospel. Be still, and try to take it all in, this astounding news of the Creator of all things entering into our world in bodily form. Like the shepherds contemplating the first Advent, this is news that should stop us in our tracks, something before which perhaps we should stand at attention!

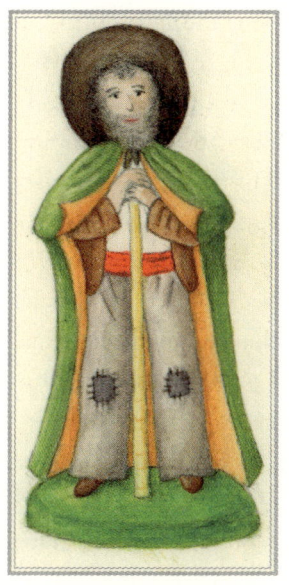

The shepherd

My shepherd santon stands with his hands clasped together over his cane. I like to think he sees himself as a sheep before his shepherd, praying, "Lead me in your truth and teach me, for you are the God of my salvation; for you I wait all the day long" (Psalm 25:5). It's a countercultural posture in a world where people's worth depends on their ability and productivity, where time is money, and hence stopping is costly. Yet, as John Milton wrote, "They also serve who only stand and wait." The shepherd santon may be immobile, but he is *not* unresponsive, nor useless, for he isn't simply standing; he is keeping watch! When shepherds retreat to the hills, and in solitude hearken to the good

news the angels bring, they show themselves to be masters in the art of living in Advent. Theirs is a stillness, and service, of standing watch.

In a grand display of theological imagination, the Provençal stories place the shepherds not in the field, as Luke has it, but on the hilltops. This is why, when they descend to enter the villages, they have a certain glow, an inner joy that burns bright, not unlike Moses coming down from Sinai with the tables of the Law, when "his face shone because he had been talking with God" (Exodus 34:29). Incidentally, this was not the first time Moses had met the Lord on a mountain. The Lord first came to Moses when he "was keeping the flock of his father-in-law" and led them to "the mountain of God" (Exodus 3:1-2).

I ponder these stories of shepherds and wonder: Can I, should I, an everyday saint, keep watch like shepherds, not necessarily on a mountaintop but wherever I am, perchance to meet the living Lord?

Play Your Part

Once you have found a quiet place and eliminated the distractions, ask God to show you how to wait, watch for, and welcome him this Advent. Don't put it off a moment longer: practice waiting for and attending to God in prayer. Be still. What happens if you wait for his voice just one minute . . . five minutes . . . ten minutes? Don't be discouraged: waiting upon the Lord (praying) is hard work. Dare to be a David—another shepherd!

Day Nineteen

HOW I LEARNED *to* BE ADVENTISH (Part 3)

My soul waits for the Lord more than watchmen for the morning, more than watchmen for the morning.

Psalm 130:6

In the beginning of my own Advent pilgrimage as a lost teenaged sheep, I watched and hoped, often on a hilltop, more than watchmen for the morning, for a living God. Once, while contemplating the canopy of evergreen trees lower down, and listening to the rivulets and echoes of distant sheep bells wafting up from below, a profound sense of joy prompted me to hope, for the first time, that there was more to this earthly life than the chronic meaninglessness from which I suffered. Surely, there must be some reality out there to which my deepest longings corresponded and were directing me.

The beauty that met me in the stillness of that solitude compelled me to confess then and there: "I believe in God, maker of heaven and earth!" And just like that, I was no longer an agnostic. I now realize those painful longings, that restlessness of heart, were there for a

reason. With Christians everywhere, I now resonate with John Baillie's prayer, "O Lord, I thank thee that thou has so set eternity within my heart that no earthly thing can ever satisfy me wholly."

Mountains, though a good start to a Christian conversion, are of course not sufficient to make known the God who came to earth to meet with us personally. It took a few more seasons, and many more solitary walks conversing with the unknown God of my familiar hills, before I came to know the *personal* God, the one who advented—came to a manger on earth—for us, for me! My early childhood questions about Jesus in the manger played an important role in this discovery: What did his cradle have to do with the Creator of heaven and earth? Though I was unchurched, I vaguely knew that Jesus' story was in the Bible, but I couldn't put two and two, Son and Father, together.

I finally did the math—once I found a Bible. I eventually learned the babe in the cradle was the same Son through whom the world was made (John 1:10). I was committed to reading the Bible, starting at the beginning with Genesis, all the while searching for God more than watchmen for the morning, praying for answers. I quickly saw the beauty of a God so holy that—alas—I knew I would not be acceptable to him. There was no functioning temple in Jerusalem anymore where I could make atonement for my sin. God was holy; I was not. I did not yet understand all I was reading, and certainly not the way forward. I asked God to help me, and the Lord answered. He sent me a shepherd, a local pastor, who showed me the way beside the still water—the living water—of the gospel that restored my soul.

The God of all grace can speak to us however he chooses to do so. Yet I sometimes wonder whether I would have heard the voice of my

Lord without those long solitary times wrestling with the deep questions in my heart, waiting for him, more than watchmen for the morning. The shepherd santon reminds me that being adventish means looking for those "away places" where I can resume my conversation with the living God.

Ponder

Now that you are familiar with the art of keeping watch in solitude, chasing all distractions away, and waiting in prayer, you can focus on something that will fill this space: letting God advent—dwell richly in—your soul, through his Word also. Practicing the art of living in Advent begins with creating the space and time for dwelling in God's Word, and letting God's Word dwell richly in us (Colossians 3:16). Can you, with J. I. Packer, see that "The healthy Christian is . . . [one] who has a sense of God's presence stamped deep on his soul, who trembles at God's Word, who lets it dwell in him richly by constant meditation upon it, and who tests and reforms his life daily in response to it." Can you imagine yourself carrying his presence throughout the day and letting it dwell in you, by carrying his Word in your heart—and waiting for him? Have you ever thought of devotion in this way before?

Day Twenty

At TABLE *with* GOD

"Behold, I stand at the door and knock. If anyone hears my voice and opens the door, I will come in to him and eat with him, and he with me."

REVELATION 3:20

Christmas, with its feast, is almost here. We wait with joyful anticipation, not simply for the food, but also very much the fellowship. Yet as we practice our solitary keeping watch, we have to admit tables are often deserted. We lead busy lives, filled with business lunches (or often just business, no time for lunch), and all too often family members grab dinner at different times. Sometimes it may feel easier simply to skip meals, rather than be bothered either with preparations or the loneliness of eating alone.

I like to think that solitary shepherds, in the silence of meadow or mountain, would have known that they were not alone, even when they ate alone. They saw the heavens above declare the glory of God (Psalm 19:1). There are other santons in my crèche, however, who do look lonely. I worry that they may not always have dinner

companions on their pilgrimage, yet they are heading closer to Jesus, and I find this comforting.

How do everyday saints cultivate the art of eating in solitude with a joyful awareness of the presence of God? Perhaps by letting Jesus' words dwell richly in their hearts: "I stand at the door and knock. If anyone hears my voice and opens the door, I will come in to him and eat with him" (Revelation 3:20). I wonder: Have we overly spiritualized this wonderful promise? What if he actually meant it more literally? What if, once we invite him into our lives, into the manger of our heart, he becomes our constant companion, even when we are alone at table? Would that change the way we eat? Would it take the sadness of loneliness away and turn it into a gentle joy, a source of refreshment? Might we even look forward to such moments?

We eat not just for bodily refreshment, but also for fellowship. Our tables feed our souls. Yet as Ingrid Friesen Moser, a registered dietitian says, "When that is not possible, eat in the presence of the holy. Light a candle or place yourself in harmony with God's creation by eating outside, near a window or with a flower or plant. Each eating experience should include a time of centering, remembering God's goodness and offering an expression of thanks."

Eating alone here becomes an act of remembrance of God's goodness—not the goodness of God poured out on the cross, but the goodness of God poured out in crops, fields, and gardens that feed the earth. The Lord will provide food, yes, but also his presence; our part is to master the art of joyful waiting, certain of God's goodness, and aware that every good gift comes from him, even when alone.

Advent is a good time to practice this art of eating in joyful solitude when we happen to be alone, and experience the presence of the Lord when the Christmas company is not yet here. This is a simple way to train our hearts to depend on the Lord to provide not just food but everything we need, a way to remain thankful even as we wait to receive our Christmas gifts, a way to remember that the greatest Christmas gift of all is Jesus, the gift of God, knocking at the door of our hearts.

Play Your Part

Practice hospitality to the Lord at the table: strive to receive him anytime you eat a meal, even during your meals alone. Consider making it a daily discipline, of being a guest of his, and of him being a guest of yours, right there at table. Ask yourself: If I eat while running, driving, working, or watching a screen, am I losing out on the sweet communion with him? It may not be the Lord's Table where we celebrate, with others, on special Sundays, but it is nonetheless a communion table for that.

Day Twenty-One

ATTENDANTS

Even though I walk through the valley of the shadow
of death, I will fear no evil, for you are with me.

PSALM 23:4

As we near the end of Advent, crèche keepers continue to move the shepherds and their sheep gradually closer to the bed of hay and thyme. The other figurines in the nativity scene interrupt their work, step back, and let them pass by, looking at them with awe and wonder. Upon closer inspection, some of these nativity figures resemble monks and priests, never mind the anachronism of the scene. Not surprisingly, there are controversies among my compatriots about these additional figures: How could there be clergy in the crèche when, at the time of the first Advent, the reason for their vocation was not yet born?

We can bypass this debate altogether by delighting in the shepherds, who after all gave their name to our pastors, shepherds of their local flocks. They, too, go up to the mountain of the Lord in solitude, to speak and listen to God in prayer, the better to look after their sheep.

"The LORD is my shepherd" (Psalm 23:1). The one laid in a manger, surrounded by the shepherds who first heard the good news, is the greatest shepherd of all (John 10:14). The whole reason for his Advent, his life mission, was to rescue lost sheep (Matthew 15:24), one at a time, and to stay with them always, each individual one (Luke 15:4). Yet even the great shepherd needed to retreat back into solitude from time to time, to talk with his Father, and find the strength to carry out his work: "But he would withdraw to desolate places and pray" (Luke 5:16).

Everyday saints may not be pastors, but each of us has received a gift to serve the body of Christ and build one another up. But serving, encouraging, and loving one another can be exhausting, which is why, to look after others, we sometimes need to look after ourselves. We, too, need to withdraw, seeking solitude and the strength that comes from being alone with God. The French word *attendre* means "to wait for." Sometimes, to attend to others, we must wait upon the Lord, and so become his "attendants."

Pray

Lord, bring me to yourself, to your mountaintop. Keep me company in solitude; show me how to attend to you, to dwell in you, and to keep your living sap flowing through me when I come down the mountain, so that I can attend to others to your glory. Lord, make me a manger wherein my neighbors can come and discover the peace of Christ!

Advent Week Four

The ART of JOYFUL WAITING in COMPANY

Day Twenty-Two

GOD GIVES COMPANIONS

And the word of God continued to increase, and the number of the disciples multiplied greatly.

ACTS 6:7

Immanuel is close by. There is holy electricity in the air. We are right to anticipate extraordinary displays of truth, goodness, and beauty. The bloom is on the rose, but it is not yet fully opened. This is why in my amaryllis illustration one flower is open and fully painted, while the others are just emerging from the bud, undeveloped, not fully

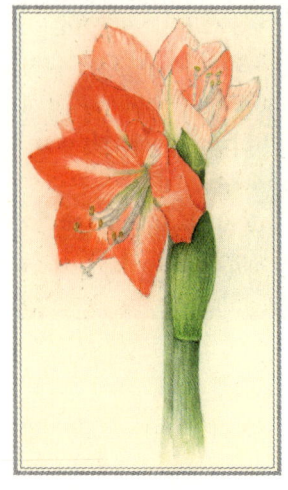

Bloom in process

colored, not yet unwrapped. Good news has been announced by the angels—the single flower trumpets it—and it will eventually gather a company.

The news the shepherds heard from the angels and shared with others led, according to Provençal tradition, to a nightlong pilgrimage, in which a great multitude of people from nearby villages went in search of the Son of God made tender flesh. They repeat the good news the shepherds heard from the angels: "A Savior has been born. Peace on earth!" So, too, with the amaryllis: the mature plant will have four similar flowers (four evangelists?), each sounding forth their message in different directions: north, south, east, and west.

Peace on earth. Peace throughout the earth. Here too, however, we must practice the art of joyful waiting, for world peace is yet to come. Still, the babe born in Bethlehem made a real difference, for even now: "We have peace with God through our Lord Jesus Christ" (Romans 5:1). What we joyfully await, and know is coming, is peace *among* people here on earth. We get a taste of this peace primarily in company with other Christ-followers. Paul opens his letters with this greeting: "Grace to you and peace" (e.g., 1 Thessalonians 1:1). Amen!

Christ-followers are on a pilgrimage, in company with other imperfect everyday saints, to completion in Christ. While solitude is an opportunity to come closer to God, so participation in the company

of everyday saints is also a means of grace, a help toward achieving the fullness of Christ, when all tribes and people and languages stand before his throne (Revelation 7:9). Christ-followers cannot remain in solitude forever on mountaintops or in their upper rooms: "It is not good that the man should be alone" (Genesis 2:18).

Human beings are created to be in company with others, particularly with others who are seeking to welcome Christ into their midst. He is the one for whom we have been waiting and preparing in solitude, the one whom we now are waiting to welcome *together*. The pastorale traditions of Provence depict the villagers undergoing changes as they make their way together, all through the night, to the manger. According to one of the subplots, peace breaks out between hitherto mortal enemies. It's a miracle! We observe the same miracle every Sunday when, in the context of worship, we pass to one another the peace of Christ.

The company is growing, their message is spreading, and God's plan for the ages is unfolding. The amaryllis, when cared for properly, grows back in its pot year after year, around Christmastime, producing spectacular beauty out of a rather homely looking bulb. New trumpets sound forth the good news year after year; the gospel tradition lives on: "How beautiful upon the mountains [and the stems] are the feet [and blossoms] of him who brings good news" (Isaiah 52:7). Thank God for his beautiful company of peace-giving messengers!

Pray

Christians can be sure "that he who began a good work in you will bring it to completion at the day of Jesus Christ" (Philippians 1:6). Paul says

this after praying with joy for the Philippians' partnership in the gospel, from the first day they heard it. Thank God today for your partners in the gospel, companions that accompany your Christian walk, praying, "Turn my imperfections into a beautiful blossom; use your saints to help transform human foibles into your glories. And help me and my companions to be living trumpets who proclaim with their lips and their lives the everlasting prince of peace."

Day Twenty-Three

A GREAT CLOUD *of* COMPANION SANTONS

So then you are no longer strangers and aliens, but you are fellow citizens with the saints and members of the household of God.

Ephesians 2:19

The Provençal nativity scene would not be half as enchanting if it were not populated by a great number of santons in addition to the shepherds. The unique appeal of the crèche may well be the diversity of those it counts as little saints. So many characters, costumes, and callings. Their colorful diversity adds to their charm—and significance. One striking feature, common to all the noëls, pastorales, and crèche scenes, is the diversity of vocations, personalities, and segments of society represented at the manger: men and women; young and old; the poor and well-to-do; mainstream and marginalized, including ethnic minorities (the Romani in nineteenth-century Provence) and those with disabilities. One manger, one Christ, one company.

These little saints do more than follow the shepherds' practice of "upper room" (i.e., mountaintop) watchful waiting. They also bring

their "lower room" practice of continuing their daily routines and regular workweek occupations. They bring both skill sets to the manger.

Some santons have obvious tangible offerings to make; others care for seeds that have not yet come to fruition. The olive woman has been tending her grove all year, joyfully anticipating its produce, and now, at Advent, she reaps the harvest that will grace the Christmas table. The musicians practice and play daily, not for a paying audience but to accompany the santons on their pilgrimage. Each person and group has a fitting gift that enriches the communion of the whole company.

A number of santons do things that complement one another, and I sometimes place them in pairs in my crèche. For example, the woman with lavender and the apothecary each benefit from the other's vocation: they make an ethnobotanical duo that minister plants to people. Meanwhile, the baker and the vintner together provide the bread and wine that gather this unlikely group of people into a real communion of saints: one body, with many gifts—and not spiritual gifts only, as we have seen.

What matters is that they keep at their daily tasks as they wend their way to and from the manger with its miracle. The art of living in Advent is to wait while working in faith that the gifts of our labor will not be in vain. While we wait for Christ to come, there is joy in everyday activity, for whatever we do, we do as a gift to King Jesus, to the glory of God. Advent may appear to be a parenthesis, a pause in the story when nothing is happening, but the reality is far different: little saints are actively waiting on the Lord, and learning to do this in Advent equips us to live and do unto God's glory in all seasons.

The diversity of little saints magnifies the Lord. Each figure brings the goods associated with his or her own vocation and offers them to the Lord, even as they offer it to each other, a small foretaste of the tribute the kings of the earth will bring into the new Jerusalem (Revelation 21:24). The Provençal nativity scene is a multifaceted parable of the kingdom of God, filled with everyday saints and small scenes of the many ways we glorify God.

Pause

Can you imagine yourself as a santon bringing a gift to the one who was and came and is to come? That is who you truly are! How might seeing yourself as a little saint who brings daily offerings to Christ, one in a great communion of saints, change the way you go about your day-to-day existence? Can you imagine your neighbor, or the person sitting next to you in the pew, as part of this same company? Do you see how what your neighbor does can be a gift to Christ and his company? Do you encourage others to develop their gifts, present them to Christ, and use them to benefit the company of Christ?

Day Twenty-Four

A COMPANY *of* FLAWED SAINTS

*Be kind to one another, tenderhearted, forgiving
one another, as God in Christ forgave you.*

EPHESIANS 4:32

Popular culture typically reserves the term *saint* for a person who behaves in an exceptionally selfless way or is extraordinarily devoted to God. Paul is not as discriminating, addressing everyone in the local churches to whom he writes his epistles as saints (e.g., 1 Corinthians 1:2). This is also how the Provençal nativity scenes think of the little saints that come to the manger.

Over the years, the pastorales and the noëls have developed sometimes elaborate stories about particular santons, who have become well-known traditional figures. They have their own names and personalities, as well as their own idiosyncrasies and individual foibles. Some are sweet, others annoying—they are oh so like you and me! A few of these characters aren't even likable. Take Marguerite on her donkey, for instance. She is so argumentative during the entire

pilgrimage to the manger that she gets on everyone's nerves. Yet the company eventually arrives at the crèche, *together*, a vivid picture of a Christian community, warts and all, pilgrim works in progress.

When a company of saints walk the Christian life, there will be moments when iron sharpens iron, making sparks fly. Yet for those who come to Christ, as he has come to them, there are also moments where iron softens iron, when flaws and foibles melt away, where "all bitterness and wrath and anger and clamor and slander" is put away (Ephesians 4:31). Little saints come to the manger to offer not simply their gifts but also their struggles and imperfections. The art of living in Advent includes learning to be kind and tenderhearted, forgiving one another, even as Christ forgives the little saints when they reach the manger! They come to be perfected and reconciled to God and to one another. Even the argumentative Marguerite eventually makes peace with her traveling companions.

The crèche may represent an unlikely fellowship, but what makes this miracle possible is the One who is at the center of the picture. In a world full of conflict and polarization, it is indeed a remarkable scene, a joyful anticipation of the new humanity and worldwide fellowship that has come into being only by the person and work of Jesus Christ, who created in himself "one new man in place of the two, so making peace" (Ephesians 2:15). As the Apostles' Creed reminds us, "I believe in the communion of saints (santons!), the forgiveness of sins . . ."

Ponder

What about the everyday saints in your own circle? Are you aware that there may be a unique story for each one, that the differences they

represent may be precisely what you need, a baker to your miller? Jesus wants us to love our neighbors, differences and all. Are you able to see other Christians who are different from you as walking in the same direction, toward the manger, with their own gifts to offer to King Jesus?

Relatedly, can you try to remember that you have your own quirks, and that, as impossible as it may sound, you may be "that annoying next-door neighbor," a flawed saint? Can you pray for God to help you see everyday saints as part of your communion? Can you see this, too, as an aspect of a lifelong project of learning to be adventish?

Day Twenty-Five

The BAKER

*And people will come from east and west, and from north
and south, and recline at table in the kingdom of God.*

Luke 13:29

The baker santon does more than bring bread out of an oven. More than baguettes, the baker bears a basketful of tradition. Bread, like wine or olives, is loaded with meaning, not only in Provence but globally. And of all peoples, Christians appreciate the significance of bread, for it is symbolic of God's provision, salvation, and promise of everlasting communion. Placing the baker santon in the crèche brings all these wonders to mind.

Some bakers are portrayed with a basket of baguettes; others offer a more rustic selection of country loaves, certainly more appropriate to the original santon period. Still others carry a flatbread with characteristic slits that people in Provence immediately recognize as the Christmas bread *la pompe à l'huile*, which appears on family tables once a year. My illustration purposely combines our daily bread with the sacred Christmas loaf. Such juxtaposition of the ordinary and the

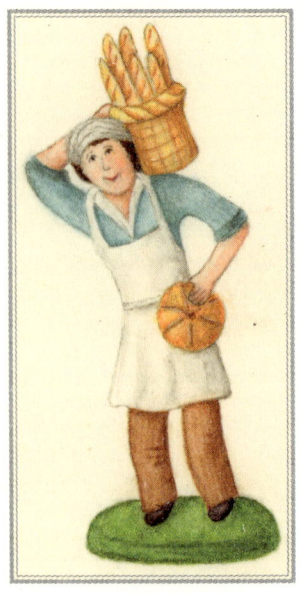

The baker

holy is precisely what the santons contribute to the traditional manger scene.

In Provence, bakers make Christmas breads from wheat and olive oil, flavoring it with orange blossom water. This bread will be *broken*, not sliced, and eaten with company on Christmas Eve. Those who take this broken bread together remember the greater story of which they are a part, much of which takes place at table, with other everyday saints, in the house of God.

The baker santon links us to the land to which we belong (our terroir), and also to the story to which we now belong, the story of the Christ child who, when fully grown, was broken for us: "This is my body, which is given for you. Do this in remembrance of me" (Luke 22:19). Jesus rightly calls himself "the bread of life" (John 6:48); he is Immanuel, "God with us" (Matthew 1:23), not just on the mountaintop, or in dining rooms, but at communion tables worldwide, wherever two or three are gathered in his name (Matthew 18:20).

Jesus, the bread of life, is himself both host and guest. We return our Lord's great gift of hospitality, by which he makes room for us at his table in the house of God, by offering our tables back to him by sharing bread—a small piece of ourselves—with others. The old French term for companion (*compagnon*) comes from the Latin terms

com- ("with") and *panis* ("bread"). A companion is one who breaks bread with you and accompanies you through the pilgrimage of life.

A local church, a companionship of everyday saints who break bread with one another at dining and communion tables, develops over time: we are kneaded together, rise together, and sometimes punched down together, all steps in the process of becoming one loaf (1 Corinthians 10:17). The art of living in Advent involves learning to wait, joyfully and with watering mouth, for the loaf the Great Baker is preparing—when we shall recline, together, at his table in the new kingdom! Until that day, we carry on with our pilgrimage, following the example of the baker santon, whose two loaves remind us that our vocations, like our lives, are at once humble and holy—everyday yet set apart, in the world yet our spiritual worship (Romans 12:1).

Ponder

The old French word hôte *means both host (who receives) and guest (who is received). The art of living in Advent involves being part of a wondrous exchange: we welcome Jesus into our places, mangers or not, and joyfully await Jesus to welcome us into his, the kingdom of God. In the meantime, we watch and wait joyfully for opportunities to welcome others into the kingdom in Christ's name, breaking bread with them and so expanding the company of everyday saints.*

Take time to ponder the wonder of being an everyday saint—one who is simultaneously ordinary (a common man or woman) and saintly (set apart for divine service). This is no contradiction in terms, but the very definition of what it is to be a companion of Jesus Christ!

Day Twenty-Six

HOW I LEARNED *to* BE ADVENTISH (Part 4)

Train yourself for godliness; for while bodily training is of some value, godliness is of value in every way.

1 Timothy 4:7-8

After I met the living Christ, I went to school. It was a school of sanctification—not marriage (Martin Luther's idea of such a school), but a Bible school, one that gathered students from around the world, mostly from Europe but also from North America, the Middle East, Africa, and Asia. The students spoke many languages and represented various walks of life. I was interested in this school, the European Bible Institute, because I had finally found a subject worth pursuing: the God of the gospel and the gospel of God!

Not long after I enrolled, one student told me,

> This school has transformative powers. Each of us starts out as a little cube in a bag with other cubes. Life will shake the bag in the days and seasons ahead, causing the cubes to collide. Some may

get scratched by the hard edges and sharp corners of other cubes. At times, it will hurt so much you will beg to be let out of the bag. However, it will gradually hurt less and less, because these sharp corners start to rub away and become smoother through constant rough and tumble, until one day (graduation), the bag is opened, and instead of cubes, round marbles roll out, each with its own pattern and swirling colors, each one a shiny beauty.

It did not take long for me to realize: I was indeed a cube. It is one thing to visit a foreign country; quite another to live there, with strangers and others. I also learned that the change from "cubidity" to roundness was neither automatic nor guaranteed, not just a matter of shaking the bag after all. Simply putting up with others would have been easy. The hard part, I realized, was waiting not for them to become round, but for myself to become a more loving person.

I was learning that sanctification is a long obedience in the same direction, a training in godliness. Part of the art of living in Advent involves learning to accept the wisdom of God's timing. Just as we must wait for Jesus, the sinless one, to come, so we have to learn to wait, joyfully, for our own promised perfection. Yes, God works miracles and changes our hearts in an instant when we're born again. Yet I slowly came to see that, in his wisdom, the Lord has decided to use our diverse companions as a means of grace for us and our sanctification.

Becoming adventish meant learning to meet saints who were different from me with joy rather than anxiety, in the hope that they would be a blessing to me, and I to them. It was an unexpected lesson. Knowledge will pass away, says Paul, but love never ends (1 Corinthians 13:8).

The most important lessons I learned in school were not in textbooks only, but also in community.

Not all my hard edges have as yet worn away. *Je suis un cube!* (I am a cube!) But the santons and their stories give me hope that I am becoming a more rounded character. Oswald Chambers confirms this important lesson in adventishness: "We look for visions of heaven, for earthquakes and thunders of God's power . . . and we never dream that all the time God is in the commonplace things and people around us."

Play Your Part

Do you sometimes feel that if you were elsewhere, with a different set of companions, things would be easier for you? Perhaps a different family, different church, different neighborhood, different workplace? Can you imagine that you are perhaps a cube refusing to become a beautiful marble? Can you ask God to use your situation, and those around you, to round off your rough edges? "And I am sure of this, that he who began a good work in you will bring it to completion at the day of Jesus Christ" (Philippians 1:6). In this confident hope, can you make it a daily project to wait with joy for the perfection in Christ that is sure to come in you and your neighbors?

Day Twenty-Seven

A DOUGHY DELIGHT

*Because there is one bread, we who are many are
one body, for we all partake of the one bread.*

1 Corinthians 10:17

When Christmas Eve is nigh, the baker approaches the crèche in company with other santons who bring food: a pot of soup, a jug of Christmas wine, freshly roasted chestnuts, a basket of little goat cheeses, even a bucket of *escargots*! And why not? The Bible repeatedly depicts food as a gift: "And God said, 'Behold, I have given you every plant yielding seed that is on the face of all the earth, and every tree with seed in its fruit. You shall have them for food'" (Genesis 1:29).

The Bible also depicts God-given food as having another purpose in addition to satisfying bodily need: fostering fellowship. Both Israel and the church enjoyed covenant fellowship with God and each other over meals, the Passover and the Lord's Supper, respectively. Food sustains our physical nature and is a social means of nurture. The table is made for food and fellowship, and we find comfort both in the meals that are prepared and in the company who shares them.

Marie Mauron, a santon enthusiast, describes a remarkable Advent scene in her novel *House of Cards*, in which the protagonists are both bakers who start their married life together by opening a small *boulangerie* in Avignon. Catherine, the wife, is a devout lover of God, land, and neighbor. She sees beauty everywhere she looks, even in her neighbors, and she wants to share her vision with others. She dreams of decorating her shop window in a way that reflects the seasons, starting with Advent. They make a bread dough crèche—and not just the manger with the holy family, either. No, she wants the whole traditional array of little Provençal saints, not as an advertising gimmick, but simply to provide a joyful scene for her neighbors.

It works: customers come every day during December to see which new santons have been added to the nativity scene overnight. Soon, the neighborhood is abuzz. The shop window becomes a joyful gathering place, even after closing hours. This excitement continues as the Advent season progresses, one little dough saint at a time.

But the biggest surprise comes on Christmas Eve, when the bakers reveal a whole new set of doughy santons that look just like people in the neighborhood. Each customer receives the gift of a miniature replica. The best gift by far, however, is that everyone now sees themselves as participants in the crèche scene, as santons who have come to adore the baby Jesus! In the crowded bakery they smile, laugh, celebrate, and more importantly, *recognize* themselves as members of this communion of doughy saints. As the author says in another book about the santons, "They all find themselves in the crèche and, in so doing, enrich it."

This fictional baker's wife is a character after my own heart, a santon who organically joins the secular with the sacred, the

humdrum with the holy, creating scenes of Advent, moments that help her neighbors to watch and wait with joy for Christ to come to their places and neighbors, as we in company with others come to Christ. She has mastered the art of living in Advent, seeing herself, and others, as part of the manger scene, part of the joyful company who, together, welcome Christ into homes, hearts, and bakers' hearths.

Play Your Part

The Christmas feast is nearly upon us. Consider how intentional you can be, not just by having the perfect present for everyone, but by helping them to see themselves as having the perfect place in the story of Christ, in the manger, with their own story to contribute to his. That is what the santon makers of old have done for me in my land. Like the baker's wife in the Advent story, try to be intentional about encouraging others around you to see the promise and the presence of the extraordinary reign of God in everyday places and everyday people. Christ has come! Christ is here! Christ will come again!

Day Twenty-Eight

CELEBRANTS

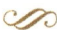

*And that night, the good Lord had never in
all his life been so happy!*

THE AUDOUARD PASTORALE

Christmas Eve is upon us; our nativity scene is set. The company of little saints are at their posts in all their humanity, frail and cracked, laden with humble gifts, yet graced with the call to be holy even in their earthly pilgrimage.

Mary has not quite reached the crèche, but her Advent waiting, surely joyful, is near its end. She and Joseph are looking for a place where she can give birth. According to one pastorale, her labor pains have just begun. Her first contraction reveals how very human she is: "Oh, Joseph! It hurts!" His fears betray Joseph's humanity too: "If the good Lord doesn't help us now, we're heading for a catastrophe." There is no company for them, no one to open a front door and invite them in to share a meal on this inauspicious yet miraculous night.

Those who keep the crèche, human and frail as well, also come to understand the miracle that is in front of them. For as they move the

santons with their gifts closer to the newborn babe, they are reminded that they, too, are summoned to participate in the story, to come and adore and lay their own gifts before the newborn King. Nearby, the three saucers of lentils in their glittery ribbons remind them that Advent is a time of waiting not only for the baby Jesus but for the wondrous work of the God who is three-in-one: the Father who sends his Son only when the time is ripe; the Son who comes for us and our salvation; the Spirit who implants the life of Christ in us as he has in Mary.

Though some might call a story that begins with birth and ends with an untimely death a tragedy, the Bible is in fact a divine comedy: a story with a happy, even joyful ending. This is why God sent his angels to the father of John the Baptist and the mother of Jesus to tell them to rejoice. To Zechariah he says, "You will have joy and gladness" (Luke 1:14). Mary sings her joy: "My spirit rejoices in God my Savior" (Luke 1:47). Yes, everyone celebrates birthdays, but followers of Christ celebrate his story's beginning, middle, and end.

The art of living in Advent involves knowing how to celebrate what has been accomplished already even when there is still another "to come." Jesus has come; Jesus will come again. It is for this reason that everyday saints do well to heed the advice of the apostle Paul: "Rejoice in the Lord always; again I will say, rejoice" (Philippians 4:4). Why rejoice twice? Because there are (at least) two things to celebrate: Advent past and Advent future. And let's not forget to celebrate the everyday Advent we can experience now.

The story therefore continues, and each everyday saint has an important part to play in it. Of course, we can't all be Mary or Joseph in the Christmas pageant. No matter. We still have a key role. For we are

all recipients of the gift of salvation, and our part is that of joyful witness to his reconciling love, which is on full display in the unlikely company we keep in his name.

Pray

Lord, help me to learn the art of living in Advent, of rejoicing in the wonderful plan of salvation, even when we have only the first fruit, the first bloom. Thank you for coming to us, and for making it possible for us to come to you. Thank you for including me and my neighbors, despite our faults and quirks, in the divine comedy of Advent.

Epilogue

ADVENT AWAY *from the* MANGER

Blessed are those whose strength is in you, whose hearts are set on pilgrimage.

Psalm 84:5 (NIV)

*A*re we there yet? Yes... and yet no. We have arrived at the end of our Advent pilgrimage with the santons of Provence. They have arrived at the manger with gifts from their land and everyday vocations. What have they taught us?

For one thing, they have shown us that we do not need to bring gold, frankincense, and myrrh to the manger. We come just as we are, offering whatever we can—all that we are. We have learned that we can come to Jesus and he to us in all that we do, in all areas of life. He has prepared a place for us, yet he also wants to come in to where we are now. We have learned the art of living in Advent when we realize we can welcome him into our lives, places, and activities anywhere and at all times.

And perhaps most importantly, we have also learned that the art of joyful waiting is not only for Advent. For though Christ has come, and the traditional Advent pilgrimage is over, we confess that he will come again. We can truly say, with John Bunyan, that our Christian pilgrimage continues to progress! For it is *sometimes* Christmas, but *always* Advent!

Our hearts are therefore set on a new hope, a new pilgrimage, and a new season of discipleship. It turns out that Advent was only an apprenticeship on how to live adventishly in all the seasons ahead. Again, the art of living in all seasons is ultimately about being ready to welcome Christ into our world whenever, wherever, and whatever we happen to be and to be doing—even as we wait for the final restoration, his second coming.

It is only appropriate that we fast-forward to the end of the story, when Jesus, his mission completed, ascends into heaven: "Two men stood by them in white robes, and said, 'Men of Galilee [everyday saints!], why do you stand looking into heaven? This Jesus, who was taken up from you into heaven, will come in the same way as you saw him go into heaven'" (Acts 1:10-11). Yea, and amen. May we therefore continue to watch and wait, with Advent and ascension joy, assured that what the angels say—good tidings of great joy—was true then, now, and always. He is coming!

This book may have started in Provence, but it ends in your own neighborhood. In the words of a benediction by Richard Halverson, US Senate Chaplain from 1984 to 1994:

You go nowhere by accident.

Wherever you go, God is sending you.

Wherever you are, God has put you there.

God has a purpose in your being there.

Christ lives in you and has something he wants to do through you where you are.

Believe this and go in the grace and love and power of Jesus Christ.

ACKNOWLEDGMENTS

I'm grateful and still astonished that InterVarsity Press approached me about writing a second book even before my first manuscript, *The Art of Living in Season*, was published. They wanted more santons stories, expanded for Advent. I am thankful for their entrusting me with this new venture, unexpectedly offering me another season of reflections upon the rich meaning of the crèche of my ancestors, perchance to bless others in the process. My editors Cindy Bunch and Rachel O'Connor encouraged and challenged me at key points in the writing, and thereby helped to improve it. Thank you, InterVarsity Press!

I have had the honor of presenting *The Art of Living in Season* to various groups through the past year, a few of which took place in seminary classrooms (thanks to Donald Guthrie and Kevin Vanhoozer), conference halls (thanks to The Center for Bioethics and Human Dignity, and the C.S. Lewis Institute), and simple living rooms (thanks to Kelly Fojtik and Carol Beitzel). Each allowed me to refine Advent, the inevitable entryway of my talks. Churches invited me specifically for Advent talks, which gave me an occasion to rehearse this manuscript and improve it: thanks to LifeSpring Community Church in Spring Grove, Illinois; CrossLife Evangelical Free Church in Libertyville, Illinois; and Moody Church in Chicago.

I dedicate this book to Tom and Gay Harris, the first shepherds on my lifelong Advent Walk. Tom came to me, when I was still searching, with an open Bible at the exact verse that miraculously opened my heart (1 John 1:9), thus awakening me to the meaning of Christmas and welcoming me into the great story. I can only explain this miracle by his regular practice of conversing with the Lord. He and his wife, Gay, talked with God, pored over his Word, and shared their gleaned wisdom with others, as they are still doing in the little Provençal village where they started their ministry. He baptized me, married my husband and me, while Gay accompanied every step of my early Christian life with prayers and words of wisdom: Discipleship 101. *Mille mercis!*

Tom and Gay drove me across France to Bible School with the gift of my first devotional book, by Oswald Chambers: *Tout Pour Qu'il Règne*. It is fitting that I pen the last word of my manuscript with the English title of this classic, for it describes the life of the everyday adventish saint:

My Utmost for His Highest!

NOTES

3 *"One might have to invent"*: Anne Marie Marine-Mediavilla, "Pour mieux comprendre Regain," in Jean Giono, *Regain* (Paris: Librairie Générale Française, 1995), 175, translation mine.

7 *Called their nativity scenes* lou Belèn: Technically, the Provençal term for Bethlehem is *Betelèn*, shortened over the years to *Belèn* with reference to the crèche.

10 *"'There is not a square inch'"*: Abraham Kuyper, "Sphere Sovereignty," in *Abraham Kuyper: A Centennial Reader*, ed. James D. Bratt (Grand Rapids, MI: Eerdmans, 1998), 488.

13 *"Remember always"*: Sharon Lovejoy, *Roots, Shoots, Buckets and Boots* (New York: Workman Publishing Company, Inc., 1999), ix.

25 *"Creation provides the framework"*: "Ordinary Splendor: An Interview with Lydia Jaeger," Lexham Press (blog), September 6, 2023, https://blog.lexhampress.com/2023/09/06/ordinary-splendor-an-interview-with-lydia-jaeger, accessed July 30, 2024.

31 *Festival of lessons and carols*: A classic Advent concert (from England, not France) in which Bible readings and carols are interspersed, relating the story of creation, fall, and the promised Savior at Christmas. It is a wonderful way of situating us at this time of the year, as the crèche does.

33 *"Living mangers"*: The *crèches vivantes*, or "living mangers," still exist, some quite famous, and are still performed in this season all the way to Epiphany. A few towns and villages, like Les Baux, are well-known pilgrimage sites for many who come, watch, and even participate by dressing and playing a part.

35 *Oldest instrument represented in the crèche*: The other common instruments represented in the crèche are the drum, the flageolet, and the Romani guitars and tambourines.

35 *Jeannette Isabelle, whose torch was inserted into a song*: The carol "Bring a Torch, Jeannette Isabella" ("Un flambeau, Jeannette Isabelle" in French) was written by Nicolas Saboly.

37 *Saboly's vocation was similar to Reformers*: Marie Mauron, *Le Monde des Santons* (Paris: Librairie Académique Perrin, 1976), 63.

42 *"Everybody should have turkey for Christmas"*: For a fuller explanation of the story, see Sylvie Vanhoozer, "Epiphany," chap. 3 in *The Art of Living in Season: A Year of Reflections for Everyday Saints* (Downers Grove, IL: InterVarsity Press, 2024).

43 *The lentils experiment*: The Provençaux use wheat or lentils, depending on what they find in their specific location and terroir. While this custom originally started the first week of Advent, nowadays most people start the second week, because of our warmer centrally heated homes that grow the seeds too fast.

48 *"Understanding the mysteries of God"*: John S. Mogabgab, "Editor's Introduction," *Weavings*, September/October 2008, as cited in *A Guide to Prayer for All Who Walk with God,* ed. Reuben P. Job, Norman Shawchuck, and John S. Mogabgab (Nashville: Upper Room Books, 2013), 370.

"Essential aspects of our stewardship": Mogabgab, "Editor's Introduction."

50 *Transhumance*: Transhumance is also an English word. Herders in many parts of the world have practiced it for centuries. It is now being reintroduced for both environmental and societal reasons, the latter because it strengthens cultural identity. UNESCO added transhumance to the list of humanity's cultural heritages in 2023. "Transhumance, the Seasonal Droving of Livestock," UNESCO, accessed August 3, 2024, https://ich.unesco.org/en/RL/transhumance-the-seasonal-droving-of-livestock-01964.

51 *"We lack the power"*: Kallistos Ware, *The Power of the Name* (Oxford: SLG Press, 1986), 18.

54 *One Advent play*: Maurel, *La Pastorale de Notre Seigneur Jesus-Christ*, Act 3.

"We are so afraid": Dietrich Bonhoeffer, *Meditating on the Word*, tr. David McI. Gracie, 2nd ed. (Lanham, MD: Cowley, 2008), 50.

55 *C. S. Lewis sees silence*: C. S. Lewis, *The Screwtape Letters* (New York: HarperCollins, 1996), 120.

57 *"Don't stand there"*: In French: *Ne reste pas là comme un santon! Fais quelque chose!*

57 *"They also serve"*: John Milton, Sonnet 19, "When I consider how my light is spent."

60 *"O Lord, I thank thee"*: John Baillie, *A Diary of Private Prayer* (New York: Scribner, 1936).

61 *"The healthy Christian"*: J. I. Packer, *A Quest for Godliness: The Puritan Vision of the Christian Life* (Wheaton, IL: Crossway, 1990), 116.

62 *Other santons in my crèche*: Sylvie Vanhoozer, "Epiphany," chap. 3 in *The Art of Living in Season: A Year of Reflections for Everyday Saints* (Downers Grove, IL: InterVarsity Press, 2024).

63 *"When that is not possible"*: Ingrid Friesen Moser, quoted in Mary Beth Lind and Cathleen Hockman-Wert, *Simply in Season: A World Community Cookbook* (Scottdale, PA: Herald Press, 2005), 210.

82 *"We look for visions"*: Oswald Chambers, *My Utmost for His Highest* (Grand Rapids, MI: Our Daily Bread Publishing, 2018), February 7.

84 *Marie Mauron's novel* House of Cards: Marie Mauron, *Châteaux de cartes* (Paris, Editions Robert Laffont, 1997).

"They all find themselves": Marie Mauron, *Le Monde des Santons* (Paris: Librairie Académique Perrin, 1976), 25, translation mine.

86 *"And that night"*: *"Et cette nuit-là, il n'avait jamais été aussi content de sa vie, le bon Dieu,"* from Yvan Audouard, *La Pastorale des santons de Provence* (Paris: Groupe Fleurus-Mame, 2010), translation mine.

"Oh, Joseph! It hurts!": Audouard, *La Pastorale des santons de Provence,* translation mine.

ALSO BY THE AUTHOR

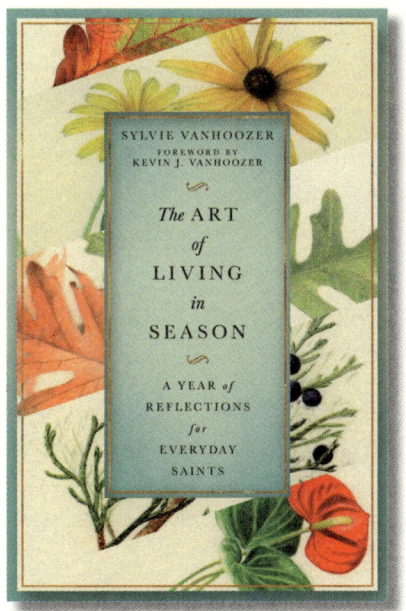

The Art of Living in Season
978-1-5140-0696-2

BECOMING OUR TRUE SELVES

The nautilus is one of the sea's oldest creatures. Beginning with a tight center, its remarkable growth pattern can be seen in the ever-enlarging chambers that spiral outward. The nautilus in the IVP Formatio logo symbolizes deep inward work of spiritual formation that begins rooted in our souls and then opens to the world as we experience spiritual transformation. The shell takes on a stunning pearlized appearance as it ages and forms in much the same way as the souls of those who devote themselves to spiritual practice. Formatio books draw on the ancient wisdom of the saints and the early church as well as the rich resources of Scripture, applying tradition to the needs of contemporary life and practice.

Within each of us is a longing to be in God's presence. Formatio books call us into our deepest desires and help us to become our true selves in the light of God's grace.

LIKE THIS BOOK?
Scan the code to discover more content like this!

Get on IVP's email list to receive special offers, exclusive book news, and thoughtful content from your favorite authors on topics you care about.

IVPRESS.COM/BOOK-QR